ART HISTORY AND
EMERGENCY

With thanks to Frederick W. Beinecke for his insightful and committed service as trustee chair of the Clark's Research and Academic Program from 1999 to 2016, under whose auspices Clark Studies in the Visual Arts *has been published.*

ART HISTORY AND EMERGENCY

Crises in the Visual Arts and Humanities

Edited by David Breslin and Darby English

Sterling and Francine Clark Art Institute
Williamstown, Massachusetts

Distributed by Yale University Press, New Haven and London

This publication was conceived by the Research and Academic Program at the Sterling and Francine Clark Art Institute. A related conference, titled "Art History and Emergency," was held 7–8 November 2014 at the Clark. For information on programs and publications at the Clark, visit *www.clarkart.edu.*

Produced by the Publications Department of the Sterling and Francine Clark Art Institute
225 South Street, Williamstown, Massachusetts 01267

Thomas J. Loughman, *Associate Director of Program and Planning*
Anne Roecklein, *Managing Editor*
Ashton Fancy, *Publications Assistant*

Designed by David Edge
Layout by Carol S. Cates
Copyedited by Sharon Herson
Proofread by Lucy Gardner Carson
Printed by Kirkwood Printing, Wilmington, Massachusetts
Distributed by Yale University Press, New Haven and London
www.yalebooks.com/art

Printed and bound in the United States of America
10 9 8 7 6 5 4 3 2 1

Title page and divider page illustration: Peter Paul Rubens (Flemish, 1577–1640), *Hercules Strangling the Nemean Lion*, c. 1620. Red, yellow and black chalk, brush and red ink, and gouache on paper, 12 1/2 x 19 1/16 in. (31.8 x 48.4 cm). Sterling and Francine Clark Art Institute, 1955.992

Library of Congress Cataloging-in-Publication Data

Names: Breslin, David, editor. | English, Darby, 1974–, editor. | Sterling and Francine Clark Art
 Institute, issuing body.
Title: Art history and emergency : crises in the visual arts and humanities / Edited by David Breslin
 and Darby English.
Description: Williamstown, Massachusetts : Sterling and Francine Clark Art Institute, 2016. | New
 Haven : Yale University Press | Series: Clark studies in the visual arts | "This publication was
 conceived by the Research and Academic Program at the Sterling and Francine Clark Art Institute.
 A related conference, titled "Art History and Emergency," was held 7–8 November 2014 at the Clark."
Identifiers: LCCN 2015045975 | ISBN 9781935998259 (publisher: sterling and francine clark art institute)
 | ISBN 9780300218756 (distributor: yale university press)
Subjects: LCSH: Art—Historiography. | Art—Philosophy. | Humanities—Study and teaching
 (Higher) | Education, Higher—Aims and objectives.
Classification: LCC N7480 .A74 2016 | DDC 700.1—dc23 LC record available at
 http://lccn.loc.gov/2015045975

Contents

Part Four

Introduction

David Breslin and Darby English

There is something hyperbolic in the evocation of "emergency" when not applied specifically to humanitarian and ecological crises. As this introduction is being written, thousands of displaced persons fleeing war and conflict in the Middle East are attempting to gain some form of sanctuary in Europe. Pictures of the displaced met at borders by police in riot gear are cruel reminders of the most notorious "state of emergency" of the twentieth century: the one Hitler declared after the Reichstag fire of 1933, which indefinitely suspended the Weimar Constitution and set the stage for stripping citizenship from those deemed insufficiently German. The rest is the untenable rationale and horror of the concentration camps. It is also the condition that led Walter Benjamin to his famous construction: "The tradition of the oppressed teaches us that the 'state of emergency' in which we live is not the exception but the rule. We must attain to a conception of history that is in keeping with this insight."[1]

So how is emergency being used in the context of this volume, one that attempts to assess art history's specific roles and responsibilities with regard to the condition widely described as the "crisis" in the humanities? At the risk of analogizing egregiously, the claiming of emergency was a way—perhaps too coyly, but nevertheless sincerely—to invoke Benjamin's key lesson that there is nothing exceptional about a condition of emergency. For those who have lived through, participated in, or are even half-aware of the various—and real—disciplinary emergencies declared in the wake of, for example, deconstruction, visual studies, AIDS activism, and the so-called global turn, the ever-recurring claim of crisis lost novelty long ago. This is not to equate humanitarian catastrophe with a discipline's internecine skirmishes. The ambition is to ask for "a conception of history" that *historicizes* its own emergencies and crises as it tumbles along to the next.

The popular press has been reporting on the demise of the humanities for some time. Styles of argument vary, but many blame economic conditions for a profound shift in the perception of higher education as primarily a vocational training ground. The *New York Times* cited Pauline Yu, president of the American Council of Learned Societies (ACLS), for her observation that "college is increas-

ingly being defined narrowly as job preparation, not as something designed to educate the whole person." As funding bases erode, public universities are paring humanities offerings. Harvard University recently reported a 20 percent decline in humanities majors over the last decade; and many matriculating students who intend to major in humanities ultimately graduate in other fields. Elsewhere, humanities offerings are being redesigned to sustain student interest. The same *Times* article quoted Andrew Delbanco of Columbia University: "Both inside the humanities and outside, people feel that the intellectual firepower in the universities is in the sciences, that the important issues that people of all sorts care about, like inequality and climate change, are being addressed not in the [humanities] departments."[2]

This volume addresses the role art history plays in this situation and the development of strategies for dealing with it. It also asks where in our disciplinary midst the champions and patrons of humanities research might emerge. In framing this volume, the art historians, curators, and artists were invited to address—from their various professional, geographical, and political points of departure—a series of questions regarding both the practical impacts of the economization of knowledge *and* the historical and methodological dimensions of "crisis." Those questions included: What role has "crisis" played in the history of the humanities? How are art historians in particular responding to the current pressure to prove their worth? By this we mean, What are we doing, and how effectively? How does one demonstrate and defend the practical "value" of knowing how to think deeply about objects and images without losing the intellectual intensity that characterizes the best work in the discipline? Is art history defensible? What's the point?

The contributors took these questions to a variety of historical, methodological, and cultural sites. Defining the crisis occupies the thoughts of the first three essays. Thomas Crow questions the validity of even calling the status of today's field an "emergency" as he looks at the "crisis" of the discipline in the 1980s that led to its great renaissance. Could we too be experiencing a similar situation today? Kajri Jain suggests that any "crisis" may be more regional than global and points to an "emerging market" in India, where she notes that the number of art history and visual studies degree programs has increased significantly. Molly Nesbit uses the example of her home institution, Vassar College, to illustrate how after the Great Depression there was a greater commitment to education and the humanities, while after the recession of 2008, there were only cuts to budgets and restructuring of priorities.

The use of art as a tool and a means concerns the authors of Part 2. Caroline Arscott discusses the instrumentalization of knowledge and new requirements to secure public funding in the United Kingdom rooted in the "impact of research." Anatoli Mikhailov takes a philosophical approach to rethink the implications that a work of art has for human beings, and Mary Miller seeks new ways to structure knowledge for students in the twenty-first century through works of art in university settings. Can we—should we—return to works of art as a source of inspiration?

Howard Singerman, Patrick D. Flores, and Manuel Borja-Villel consider values, both in terms of works of art and in terms of the field. Singerman approaches "the new art history" as a move from the structured discipline of art history to a more nebulous, interdisciplinary "department" and suggests the advantages that the latter can bring to the field. Flores reflects on the notion of "art-historical alterity" as a foil to the plea for an "alternative art history" and looks to art scholarship from Southeast Asia to consider other methods for understanding the place of art in the world. Borja-Villel engages contemporary aesthetics to consider changes in the value of art in response to today's market forces.

Part 4 of *Art History and Emergency* provides different forms of perspective on the crisis. During the conference, Our Literal Speed, a text and art enterprise located in Selma, Alabama, presented *Emergencia*, a film about contemporary academia. Following the screening, artist Theaster Gates gave a brief talk based on the Center discussed in *Emergencia*. The film's script and a transcription of Gates's impromptu response are presented in the volume's last pages.

It is worth remembering that Walter Benjamin, attempting to survive his own emergency in Vichy France in 1940, invokes Paul Klee's 1920 drawing *Angelus Novus*—"an angel looking as though he is about to move away from something he is fixedly contemplating"—as his model for history. In "Theses on the Philosophy of History," the thesis on Klee's angel of history follows just after the claim for emergency's unexceptionalism. How much useful and important writing, thinking, and making have used this intersection of art, art history, and emergency as a starting point? Instead of thinking of disciplinarity and art history *despite* emergency, perhaps this volume's most important claim is that emergency is the precondition for analysis and radical repositioning. After Benjamin's insight about emergency as rule, he mandates that "it is our task to bring about a real state of emergency."[3] Notice his claiming of the task. Notice that the efficacious emergency will come from within.

1. Walter Benjamin, "Theses on the Philosophy of History," in *Illuminations*, ed. Hannah Arendt, trans. Harry Zohn (New York: Harcourt, Brace & World, 1968).

2. Tamar Lewin, "As Interest Fades in the Humanities, Colleges Worry," *New York Times*, October 30, 2013, http://www.nytimes.com/2013/10/31/education/as-interest-fades-in-the-humanities-colleges-worry.html?_r=0 .

3. Benjamin, "Theses on the Philosophy of History."

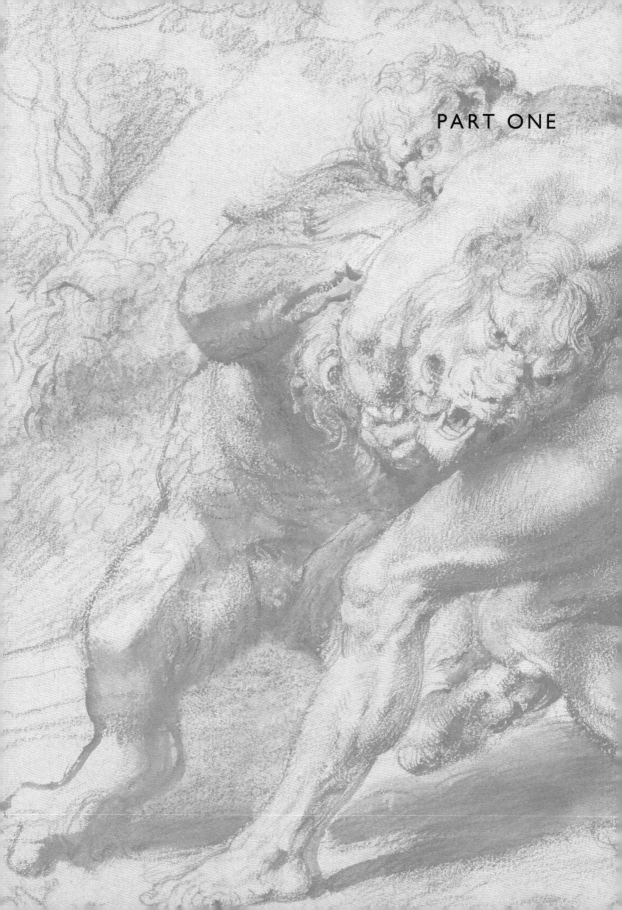

PART ONE

The Perpetual State of Emergency: Who Benefits?

Thomas Crow

Emergencies are bred by crises. When was it that a "crisis" in art history was first perceived? On the evidence of a recent report on the state of the field in the *Art Bulletin*, flagship journal of the American discipline, the first sounding of the alarm took place with the appearance in 1982 of a special issue of its sister publication, *Art Journal*, bearing the rubric "The Crisis in the Discipline."[1] Why, we should wonder, did this erupt in 1982?

By any clear-eyed assessment of art history's intellectual evolution, the early 1980s was surely one of its bright spots, a striking juncture for the quality of newer work in the field: I would judge that there was then, by an order of magnitude, more interesting reading to be done in art history than there had been a mere decade before. And these were books, not short-winded articles, and books that repaid close attention, both to intellectual quality and to literary style, as opposed to the almost willful dryness and impersonality of decades past.

Such was the extent of this change that prominent academics from other fields took notice and looked to make alliances with those they regarded as the best emerging voices in art history. The widely mooted development of New Historicism in literary studies modeled itself rather patently on the social history of art as established during the 1970s. During the early 1980s, when I was on the Princeton art history faculty, one bright spot in that experience came via the cross-departmental program in European Cultural Studies, as overseen by Carl Schorske and Anthony Vidler—which seemed for a long time to revolve around the Revolution of 1848 as viewed through the lens of T. J. Clark's 1973 books on the art of that moment.[2]

So, why would this moment count as a crisis in the discipline? Why not better see it as a remarkable, almost unrepeatable moment of opportunity and possibility? We could start by contrasting circa 1982 with the mainstream of art history over the previous several decades. I recall our late friend Oleg Grabar referring in conversation to the ascendant art historians of that period as the "no-competition generation." One of its most prominent members, he nevertheless shook his head in rueful recognition of the reign of mediocrity ushered in by the overly rapid expansion of the field after the war. That was the time when members

of other humanities departments tended to regard art historians as backward distant relations. What I am asking is: Why was *that* state of affairs not "the crisis" to which the rapid improvements evident by 1982 were the promise of a solution? It was a slow-moving, low-temperature crisis, to be sure, but slated to be fatal to the field if it had gone unchecked, had it not been arrested by timely interventions of strikingly good, unsanctioned new work.

So was circa 1982 then a phony crisis, something just mistaken or made up? That would be too pat a conclusion from what I have been suggesting. There had to be some kind of crisis or crises, or the catch phrase would not have resonated. What were they? I can think of several candidates.

One: There was a crisis of automatic deference to continental European authorities as inherently superior to Anglophone art history. Prominent figures among the no-competition generation in North America traded on their tutelage under émigré scholars, as watered down as that teaching might have been. But they transformed that training-wheels version of art-historical inquiry into confines that one crossed at one's peril. Idiomatic English-speaking voices were an affront to senior figures who could claim no true voices of their own.

Two: A potential crisis loomed for established networks with a grip on who got that job or who was awarded that fellowship. Unheralded places like the Open University or the University of Leeds or University of California–Los Angeles or the University of British Columbia were too conspicuous for comfort in these hopeful developments. It was not that more out-of-the-way programs generated the new sensibility by virtue of being out of the way; most indeed remained unaffected by it. But it never could have taken root within the established inner circle, where vigilant policing of unsanctioned innovation remained in force.

What then composed the new sensibility? For now, the answer will need to be brief. If you were not part of it, some things you might not expect were crucial. The hardline analytical Conceptualism of the early Art-Language group, first fostered at the Coventry College of Art in the United Kingdom, is one example. Also in the English Midlands, the first articulation of cultural studies played a big part, converging with the more traditional history-from-below of Louis Chevalier and E. P. Thompson. The semiotics of Roland Barthes was as influential as any body of thought, and I think I wrote my first graduate paper in the mid-1970s on Michel Foucault. Psychoanalytic feminism exemplified by Juliet Mitchell provided a large input. And there was, of course, the contribution of Marxian political economy, which ran through all the elements I've just mentioned and sets tongues wagging to this day.

I should emphasize that this was no menu of choices; rather a continuing, experimental work of synthesis. For those unversed in or hostile to these ideas, the whole enterprise was incomprehensible. Its goal was a grown-up art history, a field at home in the post-1960s intellectual landscape. This bears on a third actual crisis of 1982: a potential breakdown of credentialing in a discipline where this function had always been closely and narrowly held. It was the old story of guild structures and mentalities where claimants advancing on merit alone, especially merit beyond an agreed norm, threaten network conferral of position and status.

To the extent that these things mattered to you—and they mattered to quite a few no-competition fixtures in art history—then it would make better sense than the usual outright rejection to get in front of "the changes" in the field, seeming to credit their positive effects while casting *them*, not the longstanding dysfunctions, as symptoms of something unpleasant and unwelcome: a "crisis." That maneuver can also be said to have called into being a new subfield, the "crisis" specialist, a sort of stormbird thriving on the perception of dysfunction, always eager to dramatize difficulties, then arbitrate and explain them to the perplexed. Such a person, not usually known for substantive research productivity, would have little interest in the perceived emergency ever coming to an end.

Here is a passage I published back in 1989 that makes a similar point:

> [T]he received image of art history is of a genteel, barely intellectual pursuit, untouched by theory or even self-reflection. . . . This is a common enough perception among our extra-departmental colleagues, but has been sharpened in recent years by its repetition among art historians themselves. Such a picture has been given currency by, among others with wide influence, the administrators . . . of the new Getty Center for Art History and the Humanities, who explain the mission of their resident research center not in terms of the health of its core discipline, but of its decrepitude. The strong implication of their pronouncements has been that only by means of large infusions of money, organization, and intervention from wise outsiders, can this discipline be saved.[3]

You can tell I'd written off any idea of ingratiating myself with the entity that later became the Getty Research Institute (GRI) or that I could have anticipated eventually becoming its director for seven years. What I certainly did not want to continue was the assumption that the mission of the GRI required its object—art-

historical research—to be seen in a therapeutic frame (helping institutions can acquire a vested interest in a perception of crisis so as to enlarge their own importance). In my experience, the many Getty Scholars who came to us from other disciplines generally had more to learn from art history than the art historians had to learn from them.

That had been the thesis of *The Intelligence of Art*,[4] the book I published just prior to my coming to the GRI, which set out to demonstrate that the primary resources of the field's renewal and vitality already lay within its own, underestimated history—though I hoped the chapter on Lévi-Strauss would acknowledge the large but not exclusive role such thinkers played in the actual art history renaissance of the 1970s and early 1980s.

But I want to go back to the 1989 essay from which I just quoted. Its occasion had been a large and ambitious gathering addressed to the troubled state of the humanities as a whole. It was convened at the National Humanities Center under the auspices of the American Council of Learned Societies (ACLS). The perception of emergency came then on two fronts. Several will sound depressingly familiar: declining numbers of college humanities majors compared to some past benchmarks; the evaporation of jobs awaiting graduate students; administrators' cost-cutting indifference to specialized pursuits; the growing relative prestige of the STEM disciplines (though no one used that term then). The other front lay on ideological terrain: the gradual inclusion of heretofore underrepresented constituencies—women, the openly non-straight, and members of ethnic minorities—had provoked a delayed but fierce neo-conservative assault in the age of Reagan, exhibit A being *The Closing of the American Mind* by Allan Bloom, which came out in 1987.[5]

The conference organizers sought to counter this by a show of liberal-minded magnanimity, actually inviting Lynn Cheney to keynote the event. Then the nepotistically appointed head of the National Endowment for the Humanities, Cheney delivered a predictably scolding message that this whole "race, class, and gender" thing was now out of bounds, and, if we knew what was good for us, we would re-enlist in the ranks of "traditional" scholarship. The exchanges during the question period were as mutually uncomprehending and unedifying as you might imagine.

Prominent in all the discussions was Chicago-based Gerald Graff, then the prime stormbird among literary scholars, whose chief contribution was an incessantly repeated dictum: "Teach the conflict!" These efforts on Graff's part

to patent a magic catch-phrase, splitting these particular differences, now reappears in the present on the lips of biblical creationists seeking under this slogan to smuggle delusional superstition into the science curriculum of American public schools. These are people who want a respectful hearing in classrooms for their claims that the earth is 6,000 years old and that dinosaurs and humans lived at the same time. This proved to be a cautionary case of what can follow from misconceived efforts to accommodate the irreconcilable and an object lesson in the self-interested, parasitical character of so much crisis discourse, which harms its object more often than it helps. The misguided reaching-out to Lynn Cheney similarly points to the futility of well-intentioned efforts to meet neo-conservative assaults halfway: 50 percent on your feet will turn into 90 percent on your knees, and you will still not have accommodated these forces sufficiently for their liking.

———

For someone who regards the enterprise of meta-commentary on art history with suspicion, I have to acknowledge having done quite a lot of it. In the mid-2000s, I was in fact gratified to be included in an impressive group of humanists assessing their individual disciplines, this time an undertaking of the American Academy of Arts and Sciences. There were several meetings held, once again under the auspices of the ACLS, whose president, Pauline Yu, was among the contributors, as was Andrew Delbanco, another literary scholar quoted in the brief for the present Clark conference.

"Both inside the humanities and outside," as he says, "people feel that the intellectual firepower in the universities is in the sciences, that the important issues that people of all sorts care about, like inequality and climate change, are not being addressed in the [humanities] departments." This remark distils the core anxiety that had motivated the American Academy discussion. The first audience for the overviews we were writing for the academy's journal *Daedalus* was to be our own fellow members on the science and technology side.

But there are a number of ways this also comes down to a fool's game staged largely in the interests of forces hostile to free inquiry on either side (climate science, anyone?). To support this, I think I can best begin with more direct reporting. I have one acquaintance of great eminence across the board in the STEM disciplines—engineering, physics, mathematics. He may have been speaking somewhat out of school, so I will not identify him by name. He has remarked

to me that prodigious feats in raising his university's profile in his areas of expertise do not in fact greatly move the needle of institutional appreciation—certainly not as much as would comparable developments in the areas where power and influence truly reside, just as they do in the larger world: business, economics, and law.

That observation accords with my sense that Delbanco has been trapped, like too many other people, in a false opposition. The day people turn first to the humanities for policy solutions on global warming and income inequality would probably be the day they will truly have lost their way. Any pursuit will only be persuasive in its sphere of competence. No perceived zero-sum game between the humanities and the sciences serves the interests of authentic practitioners on either side. But there are nonetheless those who profit from pitting them against one another: professional cheerleaders in the manner of Steven Pinker for what they misleadingly frame as the cause of science over the humanities. They jeer with false sympathy at the usual statistics about declining numbers of majors, poor job prospects, shuttered departments, etc., but these pundits offer no more than the thinnest prognostications as to how neuroscience in particular is actually equipped to do the jobs that humanistic inquiry performs at its best.

Exacerbating this pretend conflict sells books and drives clicks, but is forced for polemical purposes to ignore the fundamental divide that genuinely separates the two spheres: simply put, science depends on the artificial language of numerical equations; the humanities depend on the natural human languages from which human subjectivity is fashioned. The philosophy of science has long recognized that there lies a great unknown beyond its powers of description. "Physics is mathematical, not because we know so much about the physical world, but because we know so little," wrote Bertrand Russell in 1927, in that "it is only its mathematical properties that we can discover. For the rest, our knowledge is negative." In a realm of abstractions, he points out, "there are no eyes or ears or brains"; hence "there are no colours or sounds, but there are events having certain characteristics which lead them to cause colours and sounds in places where there are eyes and ears and brains."[6] For science to try making its models live in which places, he says, would be like trying to jump on your own shadow.

The two intellectual domains are just made out of different things. Where they might seem to coincide, as in the capacity of symbolic logic to translate propositions into computable numbers, the skills and results of the exercise are so esoteric as to have little bearing on everyday pedagogical questions. I feel like I'm stating the obvious, but I guess it never hurts to reiterate the point, so as to see the natural sciences and what the French helpfully call the human sciences as logically

distinct and therefore not susceptible to zero-sum confrontations or takeovers (and I do not personally know any scientific or medical researchers who desire this).

I tried to accommodate this aim in some way at the start of my essay for *Daedalus* in 2006, "The Practice of Art History in America."[7] But I think now that part should have been dispensed with, because it was not and could not have been directed to the actual cognitive language of science. What I see as more regrettable in retrospect is my accommodating the general attitude that humanists' pursuits stand continually in need of justification, when none of our putative rivals is expected to meet this requirement, a perpetual cringe compounded by an unseemly eagerness to offer oneself up for an approval that will never come.

It cannot be doubted that objective circumstances in the universities and the general culture have become more severe since 1982. But these emergencies will never be addressed by anything perceived as special pleading. The unchanging nature of crisis rhetoric might lead some detached observer to conclude that the main thing humanists do is complain about their unfair treatment at the hands of outsiders, and that is the last thing one wants to perpetuate.

When you're challenged, the correct response is to fall back on your strengths, on what you can do that no one else does; it would not be to respond with compromised efforts at accommodation with idioms and skills that you do not command. That will never impress anyone, and will tend over time to weaken rather than repair a position.

What is a strength? You know it when you find it. It's something that can come only from an inner guide, going where your inquiry takes you, arrived at without fear or favor, indifferent to premature questions of utility imposed from without. It is work done for the future, not beholden to the clamor of the moment: the only respect owed the calling of teaching and research is respect that is not sought. Too exacting a demand, no doubt, given normal human behavior, but the only worthwhile standard and goal. As to whether it can be achieved in some significant measure, I would like to revert back to art history. I cannot say for certain whether a decline in salience of literary studies, for example, is something that I need to assume as my own problem: their plight could be due to some deficiency in what that discipline is offering, something in need of repair in the ways new entrants are formed, in the ways emerging scholars are advanced or not. Systems can always settle for some sub-optimal equilibrium.

What I would be in a position to know about is the formation of younger art historians, and might know, by virtue of my current position, more than most. New York University's Institute of Fine Arts (IFA) admits greater numbers of

graduate students than any comparable program, and graduate students are all we teach, so these are young people looking to enter the art professional life. No boutique or hothouse, more a busy crossroads. Owing to some peculiar twists in the IFA's recent history, I rapidly became, after arriving there from the Getty in 2007, the doctoral supervisor of more students than I think you would believe, a healthy multiple of the number ever taken on by anyone I know. This might seem a justified cause for complaint, but I cannot say I have felt it to be in any way a burden. Exposure to the remarkable variety of minds and talents among these students I have found to be the best possible source of energy. In my teaching, I encounter this every way I turn: fresh topics, real learning, unforced, experimental approaches. The young can bring it to us if they are not thwarted by a recrudescence of old-style networks and coteries patrolling the fellowship panels and search committees, invidious hierarchies and righteous group orthodoxies—all ethically wrong and as inhibiting of genuine innovation as were their equivalents in the early postwar decades. With that hopeful assumption, my everyday experience tells me that the practice of art history is in the furthest thing from an emergency state, so let us not repeat the errors of 1982.

Having stated that conclusion, I should try to identify some of the reasons this might be the case more generally. It is customary, in thinking about the prospects for independent thought and research, to assess the ways in which the growing reach of finance capital alters the conditions within which we are constrained. But we think less often about the changes that have overtaken the cultural economy considered in the broadest sense, that is, not simply its marketplace but the shifting distribution of relative salience among all its component vocations.

In the nineteenth century, poetry was a dominant art form, its most prominent practitioners national celebrities. As contemporary poetry has retreated to its currently vestigial importance, does that mean the great cognitive and emotional investments formerly carried by the medium have been subtracted from the whole? Obviously not: I think we can safely assume a principle of conservation of cultural energy. So that portion will have migrated elsewhere and in many directions. When demonstrators protested the *Death of Klinghoffer* at the Metropolitan Opera in 2014, it did not mean that the music of John Adams had been the source of outrage comparable to the tribute of anger paid to Stravinsky's *Rite of Spring* in 1913. The centrality enjoyed by the novel in America from Hemingway and Faulkner to Mailer and Bellow and Roth is becoming a thing of the past. So where is *that* quotient of energy going?

No one place, to be sure, and it will distribute itself up and down the normative vertical hierarchy from vernacular to erudite forms of expression. But it is an arguable proposition that as far as sectors of more advanced aesthetic self-consciousness are concerned, the broad heading of visual art has absorbed the largest share and continues to do so. It follows that specialists in the understanding of art—and not just the contemporary—will gain an increasingly larger brief and others will come away with a correspondingly lesser one.

My exposure to a proportionally greater number of pre-professional students in New York, at one of the concentrated nodes of the art system, may make this change more palpable than elsewhere. It is true that the President of the United States reflexively reached for art history as a prime example of an impractical student concentration. But let it be like that. Better to proceed beyond the gaze of the pundits and scolds, foregoing vain attempts at self-justification. For the sake of our own productivity and growth, it seems to me time for us to decouple ourselves from the professed plight of a generalized, heterogeneous entity called the humanities and just accept that visual art has inherited vital functions once distributed across other forms of expression, that large and growing numbers of people are drawn to art, and that it would be irresponsible for us not to seize the moment with confidence, make the most of the opportunity, and listen with only half an ear to the perpetual rhetoric of crisis.

1. Claudia Mattos, "Geography, Art Theory, and New Perspectives for an Inclusive Art History," *Art Bulletin* (September 2014), 259.

2. T. J. Clark, *The Absolute Bourgeois: Artists and Politics in France, 1848–1851* (Greenwich, CT: New York Graphic Society, 1973) and his *Image of the People: Gustave Courbet and the 1848 Revolution* (London: Thames & Hudson, 1973).

3. Thomas E. Crow, "Contemporary Challenges to Traditional Categories of Analysis in the Humanities: The Margins and the Centers," *American Council of Learned Societies Occasional Paper* 10 (1989).

4. Thomas E. Crow, *The Intelligence of Art* (Chapel Hill: University of North Carolina Press, 1999).

5. Allan Bloom, *The Closing of the American Mind: How Higher Education Has Failed Democracy and Impoverished the Souls of Today's Students* (New York: Simon & Schuster, 1987).

6. Bertrand Russell, *An Outline of Philosophy* (New York: W. W. Norton, 1927), 123.

7. Thomas Crow, "The Practice of Art History in America," *Daedalus* (Spring 2006), 70–90.

Whose Emergency?

Kajri Jain

"There is no need to fear or hope, but only to look for new weapons."
—Gilles Deleuze[1]

My question—"Whose emergency?"—is intended to simultaneously provincialize and globalize the issue of art history's response to the "crisis" in the humanities, an issue that tends to be framed in terms specific to the academies in Europe and North America. I want to ask what elements of the "crisis" or the "emergency" are indeed peculiar to these contexts, and what elements might be shared with academies elsewhere. What crises do the humanities, and specifically art history, face in other kinds of spaces with different relationships to the same global processes that affect us here in North America? And are these crises actually particular to the humanities? The gambit is that this more expansive approach might help sharpen our focus in thinking about our own location and moment: about what precisely it is we want to respond to and how, and ultimately what it is that we really want and need to defend. Further, given that this is a thought experiment whose comparativism is predicated on coevalness and co-constitution, it might also help us think about what kinds of relationships and solidarities we could be—or are already—forging in the process.

Let me start by sketching a very brief and broad-brush comparison with the situation in India, the context I know best outside North America. The first thing to note is its tiny number of university-level art history programs relative to the enormous population: I would put them in the tens as opposed to the 400-odd in the United States (though I should emphasize that I'm referring to art history programs, not studio art programs of which there are many more, but these are infrequently accompanied by a serious art history component). At the graduate level, the MA in Ancient Indian Art and Culture has tended to stand in for a more capacious art history, drawing on and perpetuating the colonial narrative of India's civilizational decline from ancient glory.[2]

This situation likely stems in part from developmental and nation-building priorities, and in part from the fact that art in India has never had the same institutional status as an index of social distinction as it has had in bourgeois Europe

and North America. If images play a role in enacting social status in India, this is predominantly via religious patronage—except among a very particular fraction of the English-educated elite that is disproportionately visible and influential in the global arena. Religion, particularly Hinduism, has always been hugely innovative and prolific in its embrace of new image-making techniques and media. And here, religion and art are not mutually exclusive: there are many entanglements between them, in terms of techniques, image-producers, and patrons (so a combination of art history and anthropology works well for analyzing such images). But at the same time, as I describe below, clashes between religious and artistic frames of value are also intensifying in the public sphere, as these frames themselves become increasingly reified. So this is a critical area of study for those of us who are interested in the changing forms, powers, and efficacies of images more broadly. A handful of more cultural studies–oriented programs in India have been turning their attention to these aspects of image-culture.[3]

The institutional value of "fine" art leading up to and during what is often referred to as the Nehruvian period (roughly the first four decades after India's independence in 1947) primarily hinged on its role in a nationalist narrative: whether civilizational, in the service of state-led nation-building or as part of the more cosmopolitan and pan-Asian outlook of Rabindranath Tagore and his influential art school at Santiniketan, or with the left-internationalist, anti-imperialist, and postcolonial slant of later modernist artists, critics, and curators. This was supplemented by the influential cultural initiatives of such institutions as the Goethe-Institut/Max Müller Bhavan, the Alliance Française, and the British Council, also operating within their own national frames. But from the early 1990s onward, these cultural nationalisms articulated with new forces, as the Indian government opened up the economy to foreign direct investment and the global market after decades of socialist-style protectionism. While the academies in North America, Europe, and Australia increasingly felt the pinch of budget cuts and higher workloads, the art market in India boomed, and both national and international funding, mostly but not all from private corporations, poured into cutting-edge art history and cultural studies initiatives there.

A key international funding source was the Ford Foundation, which gave grants to the Centre for the Study of Culture and Society, started in Bangalore in 1996; to Delhi's Sarai research center on media, urbanism, and public culture, set up in 2000 in part by the RAQS Media Collective, an internationally successful artist collective; and in 2002 to Jawaharlal Nehru University's School of

Arts and Aesthetics, also in New Delhi (at least two of its faculty members have been Fellows at the Clark). These globally networked centers, with partnerships in Europe and North America as well as Asia, have been enormously dynamic and have had a significant impact on the burgeoning scholarship on modern and contemporary South Asian art, culture, and media in the new millennium. There is little evidence so far, however, of a trickle-down effect on other historical periods (particularly the medieval or Mughal), which speaks both to the entanglement with the market and to the pressures of cultural politics in the present (see below).[4] Since then, other programs have mushroomed: just in Delhi, for instance, Jamia Millia Islamia's Department of Art History and Art Appreciation started in 2007 as part of an expanded Faculty of Fine Arts, and the Ambedkar University, also set up in 2007, has a School of Culture and Creative Expressions with an art history component. While these are state-run institutions, India has also seen a proliferation of privately run museums, such as the Devi Art Foundation (established in 2008) and the Kiran Nadar Museum of Art (2010), and independent artist/curator collectives like Khoj in Delhi (started in 1997 with funding from what was then called the Triangle Arts Trust), 1 Shanthiroad in Bangalore (2003), or the Clark House Initiative in Mumbai (2010). All of the above organizations have added to the critical mass of support for art and art scholarship—even though there are those whose dependence on overseas funding has meant that they have been unable to keep going once it ran out, while others have had to continually reinvent themselves according to perceived funding priorities.

We might read these global fluctuations in the relative institutional fortunes of art history as an index of capital's fickle attention as it turns toward an "emerging market": toward Indian capitalists, resident and diasporic, as patrons of art (people like Lakshmi Mittal, the steel magnate behind Anish Kapoor's Arcelor-Mittal Orbit built for the 2012 London Olympics), and its artists as the next new thing to feed the global difference machine.[5] As with much of the hype around emerging markets, however, it is important to keep things in perspective: while there is little reliable data to back this, by all reports India remains a minuscule part of the global art market, and it is highly unlikely that the actual amounts in terms of support for art history in India are anywhere near comparable to what is available in the United States.[6] But the effects and, importantly, the *affects* attending the relatively paltry postliberalization infusion of funds into India have been enormously different. Despite some cooling and instability after 2008, the feeling in India since the turn of the twenty-first century has been one of excitement and

possibility, fueled by the sense that Europe and America are over and now, along with China, "it's our turn."[7] This feeling is not confined to the elites but manifests in different ways across the board, including the resounding mandate in 2014 for the pro-development, Hindu nationalist prime minister, Narendra Modi. All this is a far cry from the atmosphere of vulnerability and demoralization that pervades our academies, cultural institutions, blog posts, and Facebook pages.

Or is it? The figure of Narendra Modi encapsulates the articulation of India's economic liberalization with the resurgence of a Hindu majoritarianism, shadowed by violence and repression, that had pervaded earlier anticolonial cultural nationalism but went underground in the Nehruvian era of modernization. What is relevant for our purposes is that history, art, and art history have been among the recent targets of political violence and threats to freedom of expression in India, both explicitly from the Hindu Right and implicitly via self-censorship by academic presses operating in this climate. For instance, in July 2010, as contributors were looking over the final proofs of an edited volume about one of India's foremost modernist artists, MF Husain, a Muslim, the editor told us that Routledge India had suddenly decided not to publish it. Two days earlier, Oxford University Press India had recalled a book by historian James Laine on the seventeenth-century Maratha king Shivaji, beloved to Hindu nationalists for defending his kingdom against the Mughals.[8] Laine's account of Shivaji's birth had led militant Hindus to vandalize bookstores in Mumbai, and the state government of Maharashtra banned the book. This ban was *overturned* by the Bombay High Court and then the Supreme Court following a public interest litigation lodged by the activist filmmaker Anand Patwardhan and others, but Oxford University Press recalled the volume from bookstores nonetheless. Routledge India's decision on the Husain book was a preemptive act of similar self-censorship, given that Husain's work had earlier been attacked by Hindu hard-liners, physically, in print, and online; in fact, several of us dealt with this in the book.[9] Another, more visible, instance of self-censorship was Penguin India's destruction in February 2014 of all available copies of Wendy Doniger's 2009 book *The Hindus: An Alternative History*, as settlement in a legal suit filed by the Hindu fundamentalist organization Shiksha Bachao Andolan Samiti (Save Education Campaign). The fear of right-wing political violence has become the norm in Indian academic publishing, with a few noble exceptions, such as the small, truly independent Yoda Press, which published the Husain book in India (as it happens, with no repercussions so far).

This, then, has been the flip side of India's institutional boom in art and art history. So now, what might all this have to say to the crisis of art history in North America and Europe? Let me just draw out one theme, the question of affect, or the capacities and diminutions being generated, not just by the movement of capital *per se*, but also by the efficacy of *the imagined power* of its movement: the desolation of its flight and the bonanza of its capture. What I have described is the difference between a field that is disproportionately energized by having had next to nothing and getting a little something, and another that had plenty in the age of the liberal welfare state and is now anxious about its future and nostalgic for its past (at least for those of us who are old enough to even remember what that felt like). Is our despondency similarly disproportionate—is the issue less the actual amounts of funding and more the vector of bestowal or withdrawal accompanying them? How are we dealing with the threat, real or imagined, of capital flight: of the loss of funding and the downsizing or closure of humanities departments? What is it making us do, what is it turning us into, what capacities is it enhancing, and what is it diminishing?

Consider the excellent infographic produced by University College London's Centre for Digital Humanities, which responds in kind to bureaucratic demands to justify the relevance of the humanities, strategically adopting instrumentalist and quantitative idioms, replete with statistics, pie charts, and graphs, to make a case for why "The Humanities Matter."[10] It includes a quite staggering revelation of the percentages of federal funding for humanities research in the United States and of European Commission funding for the humanities and social sciences. But even as it sends this powerful message, it also performatively reinforces the idea of funding as a measure of relevance. Can and should the value of our ideas be measured in terms of either how much is spent on generating them or how much economic wealth they generate? Should the dwindling proportion of humanities students be read as an indictment of what we do, or is this more about the massive increases in university intakes and in technical programs? Is the oft-cited argument about the large percentages of humanities graduates among CEOs and MPs disingenuous about factoring in the material base of those who feel able to study the humanities in the first place? In short, do we really want to buy in to and perpetuate the very instrumentalizations and simplifications that beleaguer us? I understand the strategic intent of such initiatives, and greatly appreciate the effort to find a language that reaches beyond our customary jargon to assert our

sympathy with the issues that the public is concerned about, and (unlike most politicians and administrators) to reimagine this public beyond its tax- and fee-paying role. But this task is a particularly challenging one, for one thing humanities people know about—art historians best of all—is the normalizing power of the *form* of representations in a situation of homogeneity and dominance. Given that now almost all our undergraduates were born after the fall of the Berlin Wall, a.k.a. the "end of History"—so their senses, sensibilities, and imaginations have been shaped in a world with no palpable alternative to the current neoliberal dispensation—and given that we cannot count on our politicians and bureaucrats to have read Martin Heidegger's "The Question Concerning Technology," we need to be really careful about how and why we defend what we do.[11] How might our institutional strategies and public engagements nurture sensibilities beyond the instrumental?

Our enmeshments with capital need to remain our contested performative ground; they cannot become our aim or our defense. Pragmatically speaking, art history still has enough friends in high places and enough entanglement in the value embodied in the art market, museums, and art-led urban revival and gentrification à la Richard Florida's "creative classes" argument to give it a certain buffer that, say, classics, languages, or philosophy do not have.[12] These are deeply compromised modes of survival, but they have been embedded in the discipline from the start, and artists and art historians, at least since Theodor Adorno, have a robust history of negotiating their relationships with the culture industry in various ways, depending on their sensibilities and politics. My point in suggesting that our little bit of turf may be relatively protected is not at all that we should simply embrace this status quo and carry on with business as usual as other departments go up in flames around us. On the contrary, I think our disciplinary history of entanglements with capital and of navigating between, on the one hand, the defense of imagination, autonomy, the functionless, the ludic, or the virtual (in Deleuze's sense), and, on the other hand, realpolitik and the culture industry, should put us in a position of strength to *resist* the discourse and practices of instrumentalization all the way up and down and right across our institutional structures. As artists and art historians, we know how to bite the hands that feed us; the other disciplines (and our publics) should be able to count on us for that. Further, this solidarity needs to include the natural sciences, which—most egregiously in Canada but elsewhere, too—have been subject to the same shift from pure research to servic-

ing the economy and, crucially, to blatant muzzling.[13] The humanities and the sciences should not be fighting over pieces of the pie in a classic divide and rule situation.

This is not simply a naïve anticapitalist pitch; it is fundamentally about academic freedom, and freedom of thought and expression more generally. The Indian comparison reveals these stakes starkly at a moment when neoliberal regimes everywhere are deploying identity politics to simultaneously institute consensus and states of exception. This unfolds either through a putatively benign multiculturalism (that purports to love artists and brown women like me, but whose terms of inclusion are tone-deaf to difference) or through militant forms of Christianity, Zionism, Hinduism, and secularism (which often has deeply Christian underpinnings), explicitly ranged against Islamic and other Others. Here economic instrumentality is entwined with the less obvious and far less easily discussed instrumentality of identitarianism, exerting pressure on what we do on a sliding scale of palpability and public outrage. Political violence, as in the Indian instances above, is the most obvious form taken by such pressure; less so is the funding of universities, centers, and positions like a proposed endowed chair in "Hindu Studies" at the University of Toronto via the patronage of "the community," or threats to withdraw donations that result in a situation like the University of Illinois reneging on its job offer to Steven Salaita.[14] Identity-based funding and political violence are similar in their censoring and self-censoring effects. We have to play the game to survive, we're told—but what precisely is surviving here? Is this what we signed up for as scholars in the humanities?

Political violence and censorship are routinized into self-censorship while the affective edge and temporal urgency of emergency are dulled into the acceptance and management of an ongoing state of crisis: the constant firefighting of departmental reviews, assessments, rankings of "excellence," operating budgets, administrative directives. Crisis is to time what spectacle has become to space: an exceptional affect that has become routinized by the ongoing threat of capital flight. Its temporality is inimical both to the slow, quiet thought that makes the world otherwise *and* to an urgent focusing of political energies. But if, as Alexander García Düttmann proposes, we were to proceed as though the university were not in "crisis" but indeed intrinsically unconditional—at once, urgently and without what he describes as "euphemism"—the act of *actually* doing our jobs would both extend the capacities of the unconditional university and at the same time amount to civil disobedience to the neoliberal institution.[15]

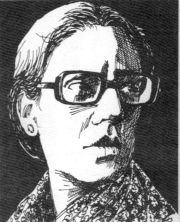

Fig. 1. Exhibition review by Alka Raghuvanshi and Sumita Thapar of *Hundred Years from the NGMA Collection*, curated by Geeta Kapur, 1994. The *Pioneer* (New Delhi, India).

One last comparison: contrast our ongoing bureaucratized crisis to India's Emergency with a capital E, a political state under Prime Minister Indira Gandhi, lasting from 1975 to 1977, that suspended civil liberties and sanctioned anti-opposition and anti-poor violence. That was a formative moment for artists, scholars, and activists, tempering their relationship to state and other institutions and galvanizing wide-ranging solidarities. Thus, the redoubtable Indian art critic and curator Geeta Kapur (fig. 1) has maintained an independent career for decades, as has the activist filmmaker mentioned earlier, Anand Patwardhan. The gadfly writer Arundhati Roy worked as an aerobics instructor to write the Booker Prize–winning *The God of Small Things*; the incomparable Bhupen Khakhar had a day job as a chartered accountant as his paintings and his persona, "calmly and adventurously" and with disarming humor, blew apart and reassembled religiosity, sexuality, and everyday life (fig. 2).

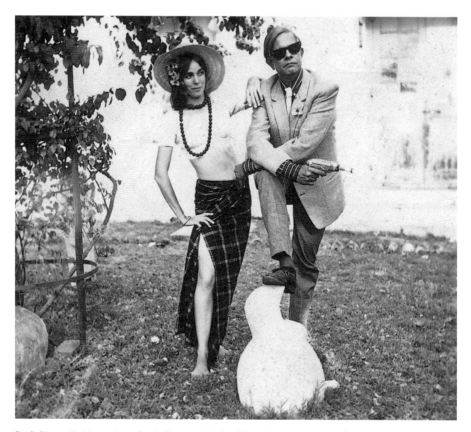

Fig. 2. Bhupen Khakhar as James Bond. Photograph by Jyoti Bhatt from the catalogue for Khakhar's solo exhibition in 1972 at Gallery Chemould, Mumbai

It hasn't quite come to that here, but the point is that—as these and many other fiercely independent, imaginative, and committed Indians attest—there are options. Do we really want to pine for the love of institutions when all *they* pine for is capital, power, "growth"? Or can we call on another set of affects, what Spinoza called the joyful passions, to productively refute routinized crisis, ghettoized politics, the colonization and reification of the imagination, and banalized evil?[16] While the affects are by definition not subject to our control, anyone who has weathered a personal crisis knows that an affective complex can be engineered, and generative conditions wrought from whatever resources one already has: in our case our work, our conversations, *and* our universities, research centers, museums, and galleries—to the extent that, galvanized by the contradictions of their existence, they still provide openings for thought and expression within an increasingly instrumentalized universe. In the face of feeling constantly and inevitably

screwed, perhaps we need to invert the colonial adage "lie back and think of England" and instead sit up and think of India. Forget the "crisis": doing art history *is* the emergency.

1. Gilles Deleuze, "Postscript on the Societies of Control," *October* 59 (Winter, 1992), pp. 3–7, 4.

2. I thank Kavita Singh for this insight and other invaluable comments, and recommend as a companion piece to the present essay Kavita Singh, "Colonial, International, Global: Connecting and Disconnecting Art Histories," *Art in Translation* (special issue: *Connecting Art Histories*), (2015), DOI: 10.1080/17561310.2015.1058022.

3. I prefer not to use the term "visual culture," given that images are not reducible to the visual.

4. Scholarship is only just emerging on the contours of the market for modern and contemporary South Asian art, but the sense so far is that most collecting is from nonresident Indians (known as NRIs), followed by a growing constituency of new local elites, rather than public institutions and the earlier Nehruvian elite. Contemporary art remains a minor percentage of the total recorded auction sales for Indian art, which could indicate that this remains a lower-end (and hence more accessible) market; certainly, the feeling is that in this respect—as in many others—India is "very far behind" China (see http://timesofindia.indiatimes.com/india/Is-Indian-art-markets-blue-period-over/articleshow/27695214.cms [accessed June 2, 2015]). For a thoughtful piece, see Manuela Ciotti, "Post-colonial Renaissance: 'Indianness,' Contemporary Art and the Market in the Age of Neoliberal Capital," *Third World Quarterly* 33, no. 4 (2012): 637–55.

5. Milestones in the development of the market for Indian art include: the commencement of specialized auctions of modern and contemporary South Asian art by Christie's and Sotheby's in London and New York in 1995; the establishment of two local auction houses, SaffronArt and the now defunct Osian's, in 2000; the first India Art Fair (formerly India Art Summit) in 2008; and the first India-based auction by Christie's in Mumbai in 2013. For a very brief overview from 2008, see Iain Robertson, Victoria L. Tseng, and Sonal Singh, "'Chindia' as Art Market Opportunity," in *The Art Business*, ed. Iain Robertson and Derrick Chong (New York: Routledge, 2008), 82–96.

6. On the difficulty of gleaning reliable data on the Indian art market, see, for instance, http://www.theartstrust.com/ArtMarket_cycle.aspx?article=5 (accessed July 31, 2015); this, however, does not prevent organizations such as the Arts Trust and ArtTactic from providing market predictions and investment advice.

7. For a sense of this hubris as refracted through Delhi's art world, see the first chapter of Rana Dasgupta, *Capital: A Portrait of Twenty-First Century Delhi* (Edinburgh: Canongate Books, 2014); or *Capital: The Eruption of Delhi* (New York: Penguin Books, 2014).

8. James Laine, *Shivaji: Hindu King in Islamic India* (New Delhi: Oxford University Press, 2003).

9. Sumathi Ramaswamy, ed., *Barefoot Across the Nation: Maqbool Fida Husain and the Idea of India* (London: Routledge, and New Delhi: Yoda Press, 2011). The volume was published by Routledge UK after fervent appeals and protests by the editor and contributors, while the Indian edition was published by Yoda Press.

10. Melissa Terras, Ernesto Priego, Alan Liu, Geoffrey Rockwell, Stéfan Sinclair, Christine Hensler, and Lindsay Thomas, "The Humanities Matter!" Infographic, 4humanities.org/infographic, 2013: http://4humanities.org/wp-content/uploads/2013/07/humanitiesmatter300.pdf (accessed Sept. 18, 2015).

11. Martin Heidegger, *The Question Concerning Technology and Other Essays* (New York: Harper Row, 1977), originally "Die Frage nach der Technik," in *Vorträge und Aufsätze* (Pfullingen: G. Neske, 1954).

12. Richard L. Florida: *The Rise of the Creative Class: And How It's Transforming Work, Leisure, Community and Everyday Life* (New York: Basic Books, 2002); *Cities and the Creative Class* (New York: Routledge, 2005); *The Flight of the Creative Class: The New Global Competition for Talent* (New York: HarperCollins, 2007); *The Rise of the Creative Class, Revisited* (New York: Basic Books, 2014); etc. On the link between the creative class model and the rise of the global university, see Tom Looser, "The Global University, Area Studies, and the World Citizen: Neoliberal Geography's Redistribution of the 'World,'" *Cultural Anthropology* 27, no. 1 (2012): 97–117.

13. See Chris Turner, *The War on Science: Muzzled Scientists and Wilful Blindness in Stephen Harper's Canada* (Vancouver: Greystone Books, 2013); one initiative to combat this muzzling is the organization Scientists for the Right to Know: http://scientistsfortherighttoknow.wildapricot.org (accessed June 18, 2015).

14. For a concise overview of the Salaita case, and specifically the role of pressure from donors to the University of Illinois, see Colleen Flaherty, "Going After the Donors," *Inside Higher Ed*, January 30, 2015: https://www.insidehighered.com/news/2015/01/30/steven-salaitas-long-anticipated-lawsuit-against-u-illinois-includes-twist (accessed June 2, 2015). For an exhaustive report, see the American Association of University Professors, "Academic Freedom and Tenure: The University of Illinois at Urbana-Champaign," http://www.aaup.org/report/UIUC, April 2015 (accessed September 17, 2015).

15. Alexander García Düttmann, "Euphemism, the University and Disobedience," *Radical Philosophy* 169 (Sept.–Oct. 2011): 43–47. Thanks to Brian Price for alerting me to this, and for his deeply engaged comments on a draft of the present essay.

16. Benedict de Spinoza, *A Spinoza Reader: The "Ethics" and Other Works*, ed. and trans. Edwin Curley (Princeton: Princeton University Press, 1994); Gilles Deleuze, "Spinoza and the 'Three Ethics,'" in *The New Spinoza*, ed. Warren Montag and Ted Stolze (Minneapolis: University of Minnesota Press, 1997), 20–33; Michael Hardt, "Spinozian Practice: Affirmation and Joy," in *Gilles Deleuze: An Apprenticeship in Philosophy* (Minneapolis: University of Minnesota Press, 1995), 56–111.

Greater Depressions

Molly Nesbit

Shadows, many shadows, overtake us like the darkness that falls when art history lectures begin. That shadow describes an ethos. Last spring I asked the students in Art 106 to try to take its picture. Note the joy (fig. 1). An ethos finds its roots in the ancient Greek word for habit and custom. With it, the Greeks generated the concept of ethics. An ethos sums up the direction to be taken by the entirety of a human culture and its life. Over time that direction, which is never singular, becomes history; a direction, full of plurality, narrative, and reflection, becomes a dynamic. At its best it is epic. Philosophy has bent itself to this territory for centuries. So much so that today we see ethos to be a word that we require for everyday existence, a word equally fundamental to the description of what an education can bring to a person. An ethos contains its own order of light. Works

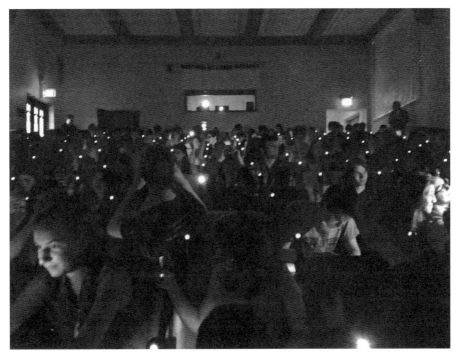

Fig. 1. Art 106, Vassar College, April 25, 2014

of art and architecture are felt to carry this charge in their very core. We show it by teaching in the dark.

After 2008, a new set of arguments requiring cost-cutting overtook American colleges and universities; the humanities have suffered mightily from them, and Vassar is no different. The polite name for it all is restructuring. Call it the restructuring of an ethos. This is pseudo-economic logic devaluing past knowledge; the logic expresses only its own values, though in code. Where art is concerned, they are the values of roving finance capital and its favorite, the luxury art market, which is presuming to become our ethos and sending its message over and over again, so that repetition will install belief. Why not speak it plain? It is the belief that art will be a compliant beauty, artists will exist to become their own brands, any public need for ethos will be reduced to the instincts of the mass market's fifteen-year-old target audience, dissent be dismissed, the past is a costume drama, memory be damned. These beliefs are finding their way as well into the art schools and the museums. Contemporary art's popularity comes at real cost to everything else.

The cost-cutting will drop the study of time from a first-order structure that dates from the early twentieth century. After World War I, American universities reset their curriculums, in part to reflect the Allies' new sense of responsibility to the world and its history, in part to install the new faith in the progressive power of education itself. Columbia's core curriculum would be one example; so would be the arrival of Art 105, the team-taught art history survey, at Vassar in 1928. When the Great Depression ensued in late 1929, the commitment to these new curriculums did not diminish: most surprising to us now is the fact that *in the face of diminished resources, the commitment to deeper, longer knowledge only increased.*

We do well to remember this. Our economic situation after 2008 is by no means as dire—that first Depression was in so many ways the greater one. We should be taking inspiration from the fact that the conception and construction of the field of art history expanded in the face of great odds in the 1930s. One sees this in the work of certain scholars, like Meyer Schapiro, who in 1936 gave us model art criticism and drew up this list of the most pressing problems facing a Marxist art history:

I. Critique of the basic concepts used today in the investigation of art
 a. race
 b. immanence of development
 c. autonomy of individual creation

It would also be necessary to criticize the various mechanical and vulgar materialistic interpretations of art.

II. Investigation of
 a. traditions of realism
 b. artists and art during past revolutionary periods
 c. the content of modern, especially abstract, art
 d. the interrelation of modern realistic arts (painting, cinema, literature)

III. Exposure of unacknowledged social and ideological bases of typical methods of art investigation
 a. connoisseurship and attribution
 b. formalistic analysis
 c. culture-historical (*geistesgeschichtliche*) analysis

IV. Critique of official academic teaching of art-history, the "iconographic" methods of the Princeton scholars, historical formalism, general tendencies of archaeological research, etc.

V. Another important set of problems are those concerning modern architecture, functionalist aesthetic, architectural reformism, city planning and housing, etc.[1]

One sees it as well in the plan that Henri Focillon put forward in early 1940 for the study of art history at Yale. In many ways Focillon's plan for a major in the history of art was an extension of the work that he and Paul Valéry were undertaking at the League of Nations. Focillon was clear: he was not proposing a department that would exist in splendid isolation, but rather, he said (in French), one founded on a collaboration with other, existing departments and defining itself as "*une organe de liaison*." An organ like the lungs, like the heart. It would introduce structure, redistribution, and an open plan into an existing condition; art would be taught as part of the education of a man, as part of his training as a researcher and a savant. Focillon saw the field geographically, temporally, and intellectually to be expansive. The open plan would not close, or lose its seriousness. His own course on method made that idea clear. George Kubler, his student, drew some of its points together on a notecard fairly exploding with big questions.

Focillon told them straightaway that appreciation was not knowledge. He told them that the work of art existed as both a fact and an object with the power to exist in continuity. No radical appeal to aesthetics or psychology, he said, was required. Focillon saw art history to be a field capable of shouldering knowledge writ long and large. It too was plunged into the mobile structure of time, the diversity of movement, and the play of metamorphoses—the *freedom* in form that the *Life of Forms* had begun to chart.[2] It was the most complete of the historical disciplines, since it rejoins the natural sciences via the instruments of observation and experiment. Kubler took all this down and in. His own meditation on the *Shape of Time* would begin with the memory of his teacher as he lay dying in New Haven in 1943, a medievalist haunted by the question, "*Qu'est-ce que c'est que l'actualité?*"[3]

The art history that was built in the 1930s and 1940s is often dismissed in clichés by those who don't read or know it very well. No knowledge is perfect. But this art history is part gold mine: our own field has layers still worth excavating in detail—techniques, tactics, and strategies are embedded there, lying dormant, waiting to take up the next generation's work on vision writ large. The present is in the past, and vice versa. Look in your own backyard.

My backyard, for example. At Vassar, the present was in the department right away after the First World War: in 1923, two exhibitions of modern art took place, both from the collections of the Société Anonyme (fig. 2) and brought there by the Princeton-trained classicist Oliver Tonks, who took the trouble to learn about Dada in order to give a lecture on modern art: Picabia bringing forward the *nec plus ultra* of cynicism in philosophy, moving beyond the need of mere

Vassar College

Exhibitions

of

PAINTINGS

by Modern Masters of
Spain, Germany, France, Russia, Italy
Belgium and America

(Loaned by Société Anonyme, New York)

April 4 to May 12, 1923

Fig. 2. Checklist for the spring 1923 exhibition from the Société Anonyme at the Vassar College Art Gallery. Frances Lehman Loeb Art Center, Vassar College, Poughkeepsie, New York

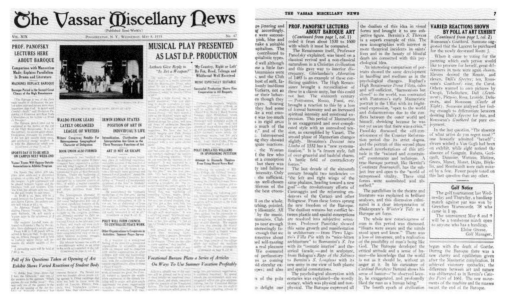

Fig. 3a, b. *The Vassar Miscellany News*, May 8, 1935, 1 and 7. Vassar College Archives & Special Collections

beauty. The picture in question was deemed too tricky to list in the catalogue: it is "Universal Prostitution." Tonks did not take sides. Lamenting the absence of Kandinsky from this show (the Société Anonyme was showing his work in their own space in New York), Tonks planned a Kandinsky show for November. That fall, the young Alfred Barr came to teach for the year. Tonks lectured again, ending this time with the word "psycho-analytical."[4] The school paper gave sustained coverage to the show and so interviewed Barr on the matter of Kandinsky's color, only to learn that he felt the artist had failed because "he does not give an emotion to the observer."[5] Barr left for Harvard. In 1927, another show of modern art was organized to go along with Modern Language Week. El Lissitzky's *Proun LN 31* was there in the mix.[6] The next year the team-taught survey course, Art 105–106, took up the pace.

The thirties saw the unmitigated growth of art history, in equal parts ancient and modern. Richard Krautheimer arrived to teach at Vassar in 1938. Not coincidentally, Erwin Panofsky gave his first lecture there in the spring of 1935 (fig. 3a, b): Panofsky spoke of the Baroque's field of contradictory forces brought to a close only by the arrival of the masses and machines; he put the forces together with Shakespeare: "Hearts were aware and minds stood apart and knew."[7] Again, not coincidentally, Le Corbusier came to speak about his work that same fall

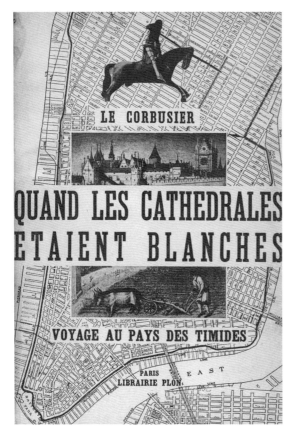

Fig. 4. Le Corbusier, *Quand les cathédrales étaient blanches: voyage au pays des timides* (Paris: Plon, 1937). Vassar College Archives & Special Collections

(fig. 4).[8] Agnes Rindge and John McAndrew were close to those working for modern art at MoMA, and MoMA itself sponsored the lecture. A version of *Cubism and Abstract Art* would travel to Vassar in 1938, but the Malevich would have been no surprise. Art history there already had a modern frame and a daily life. McAndrew would design a modern art library and classrooms and offices, completed in 1937, inside a neo-Gothic building.[9] He would see no contradiction between Breuer office furniture and Piranesi's views of Rome (fig. 5), and would not reduce one to the other. Panofsky would keep coming back (he lectured at Vassar ten times over the years); Dürer's *Melancholia* was his topic in 1942. The accumulation produced an engaged, intellectually fertile field that as a matter of curriculum has largely remained in place. Leo Steinberg was brought in to give a class on Spanish painting in the fall of 1965; his public lecture on *Las Meninas* was famously derailed by the power failure of the great Northeast Blackout, and so he mimeographed copies of his lecture as Christmas presents for his class.[10] Linda Nochlin was photographed giving an Art 105 conference section on Roman architecture (note the Piranesis again; fig. 6). She used her art history to build an entirely new set of arguments for the field in the late 1960s: it has seemed to make sense that "Why Have There Been No Great Women Artists?" would be written at Vassar in late 1970. But her questions, too, like Focillon's, were not meant to stay home.

For all this momentum, nothing was easy or guaranteed for this art history that was building new power sources in America. In early 1944, in the dreadful time before the Normandy invasion, art historians in America worried that their

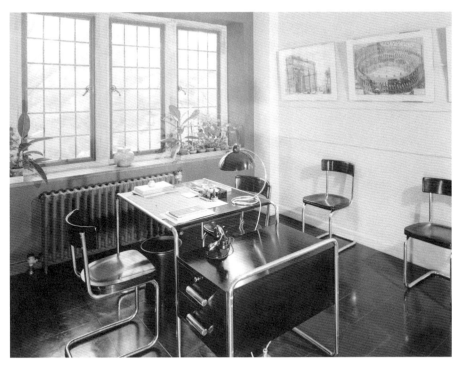

Fig. 5. Faculty office in the new addition to Taylor Hall, 1938. Interiors designed by John McAndrew. Vassar College Archives & Special Collections

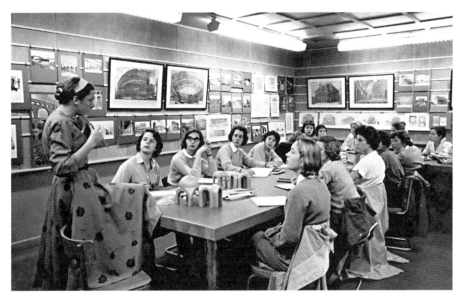

Fig. 6. Linda Nochlin teaching an Art 105 conference section on Roman architecture, Taylor Hall, Vassar College, 1959. Interior designed by John McAndrew. Vassar College Archives & Special Collections

discipline would be relegated to the scrap heap of "uselessness" by the war effort. Science and vocational training had become the new national priorities. The situation led the College Art Association to write a collective "Statement on the Place of the History of Art in a Liberal Arts Curriculum" in order to emphasize that "the growth of a democratic culture requires idealism and a sense of values among the young."[11] It is a letter intended for deans and other university officers. Signatories were Millard Meiss, Alfred Barr, Sumner Crosby, Sirarpie Der Nersessian, George Kubler, Rensselaer Lee, Ulrich Middeldorf, Charles Rufus Morey, Erwin Panofsky, Stephen Pepper, Chandler Post, Agnes Rindge, Paul Sachs, Meyer Schapiro, and Clarence Ward; represented were Columbia, Yale, Wellesley, Smith, University of Chicago, Princeton, the Institute for Advanced Study, the University of California, Harvard, Vassar, and Oberlin, as well as the Museum of Modern Art. These were then the leading scholars and art history programs of their time. Those same programs are, all of them, now still leading ones, and they are again beset by deans and presidents and trustees asking them to justify themselves, the field of study, the use of, say, Rembrandt. Can we use the old arguments? Will we say, "The history of art is an indispensable part of the liberal arts curriculum because the purpose of that curriculum is the development of wisdom, responsibility and judgment"?[12] Nietzscheans or not, we repeat and return.

To what now? We still have our perspectives of time. They show us that the economy that underwrote this expanding, largely humanistic knowledge was one based upon private donations, many from individual fossil fuel fortunes that were being turned to public good—Carnegie, Rockefeller, Mellon, De Menil. The wealthy individual of the twenty-first century is often benefiting from the same economies—the fossil fuels still generate great profits, though they are joined by technology fortunes and the new force fields of finance capitalism. This new, speculative capital and its individual beneficiaries do not feel the same sense of responsibility to the past, or to the future. Its foundations stay private. The word "wisdom" is not much used. Ours is an era of short-term profit-taking, short-term optics, and short-term words. What has happened to the collective need for vision? Our shadows now fall elsewhere.

Other perspectives open. Call them long-term; they start from the past. Art history as it took root in the 1930s did not necessarily privilege a top-down aesthetics of separation. It did not speak with one voice for an epistemology of superstructure; at the same time, it was opening the door for an epistemology of base. The study of art history, with its comparative measuring techniques and

constitutive problems, its innate transdisciplinarity, gives us exactly the frame we need right now to face the much larger questions of duration in the air, on land, and at sea. It is time to pose the extracurricular questions.

We have, as a field, much in common with geology—for very different reasons we both have benefited intellectually from the success of the fossil fuel industry. The geologists, too, examine the strata and plunge deep into the past, much deeper than we do, but they are also concerned, increasingly, with the present. An international group of stratigraphers has formed to ask a technical question about the history of the earth: whether we have entered a new age, a new rock bottom, because of man's increased presence in the earth's processes. Does the age deserve to be marked off with a golden spike and named the Anthropocene? They call themselves the Anthropocene Working Group.

In mid-October of 2014, I attended a meeting organized for the Anthropocene Working Group at the Haus der Kulturen der Welt (HKW) in Berlin. As part of their own Anthropocene Project, the HKW has published a three-volume reader, *Grain Vapor Ray*, a collection of documents and essays that extends the stratigraphers' questions into wider spheres of knowledge.[13] For this collection they had asked me to contribute an essay on Focillon and Kubler. The cultural and scientific questions of *Grain Vapor Ray* were then brought to a different stage, a weekend of live presentations grouped together as *A Matter Theater*. For that context I was invited to fill time in a dark auditorium with art's order of argument. I began with a hard, and fateful, question—What is a sustainable aesthetics?—and sent it to a group of artist friends: Tomás Saraceno, Rirkrit Tiravanija, Lawrence Weiner, Karl Holmqvist, Raqs Media Collective, Allora & Calzadilla, Olafur Eliasson, Martha Rosler, Nico Dockx, Anri Sala, Pierre Huyghe (who sent a film by Jean Painlevé), Thomas Bayrle, and Philippe Parreno. Tomás Saraceno brought live spiders into the theater, there in their webs, spotlit (fig. 7). A live video feed projected their sparkling world onto a gigantic screen. It appeared like a moving photographic negative, huge. The spiders wove and strummed in the dark for all to see. Our human program was designed to exist alongside theirs, smaller. The spiders never stopped.

The spiders' web became our baseline; their world, our measure; the spiders, our fellow travelers. We wrap ourselves variously in our nihilism, I said, by way of brief introduction to works that did not tell, only showed themselves in succession to be scenes in the larger theater of co-existence. The spiders, themselves miked up, made noise when they felt like it. Their sound periodically and

Fig. 7. Performance program during the opening night of *A Matter Theater*, part of the Anthropocene Project at the Haus der Kulturen der Welt, Berlin, October 16, 2014. The photograph shows the projection of the spiders brought by Tomás Saraceno and films by Rirkrit Tiravanija. Program organized by Molly Nesbit

unpredictably invaded ours. We deferred. We projected our images in sequences, some still, some moving, onto three smaller screens; our sound program was distributed across different tracks. The old subject–object relations kept shifting. Markets controlled nothing. Our nihilism had its several starting points in the dark, in the interruptions and the examples, all of it bathed in the spiderlight and the expanding time of art. In real time it lasted two hours.

At the beginning of the evening in the same auditorium, the stratigraphers had made their own presentations, more didactic ones. They never went narrow. The challenges for earth science were set by Naomi Oreskes in her keynote address:

> If humans are no longer insignificant [for the matter of earth science], this raises at least two important challenges for geology as a science.

The first is that its subject has changed. Indeed, topics that include the human impact on the globe are now rightly understood as part of the science. . . . The second challenge[,] however, is more complex. If humans are geological agents and conscious of their own impact[,] it inevitably invites discussion as to whether this impact is good or bad. And if the latter, it invites discussion of what one should do about it, and whose responsibility that is. This introduces the possibility that moral and ethical questions now fall within the rubric of "geological science," a suggestion that makes natural scientists uncomfortable and puts their long-held concept of value neutrality at stake.[14]

In memory now, one can put all the contributions together. But one could just as well extend them. How might art history itself enter *this* conversation and contribute to it? Which emergency do we really address? Are they not in the end the same? One order of projection could and should infect the others. These questions have no limits.

At the HKW everyone was proposing to combine wisdom with knowledge, past with present, art and science coming together before the prospect of future human life. Implicitly the idea of the working group had grown. For ourselves as art historians, we need to target a problem and set a plan of action. We need, like the stratigraphers, to work technically, concretely; we need, like the activists, to raise a call. *Pace* all the naysayers, we can do something practical for the future. Let us hurry now and pool our wisdom, past as well as present. Let wisdom set the compass. "Art is everything," Kubler once said. "All reality is part of the mandate."[15] If reality is our object, then it is as clear as day that art history is no one's luxury.

1. The list appears in Meyer Schapiro's letter to Kenneth Howard, February 5, 1936, Rare Book and Manuscript Library, Columbia University, Meyer Schapiro Collection, Series II, box 157, fol. 2. I have discussed the import of this letter, as well as other issues raised in this essay, in my book *The Pragmatism in the History of Art* (New York: Periscope Press, 2013).

2. Henri Focillon, *Vie des formes* (Paris: Presses Universitaires de France, 1934); in English, *The Life of Forms in Art*, trans. Charles Beecher Hogan and George Kubler (New York: Zone Books, 1996), 156.

3. George Kubler, *The Shape of Time: Remarks on the History of Things* (New Haven: Yale University Press, 1962).

4. The connection to Katherine Dreier and the Société Anonyme was made through Christian Brinton, who had lectured on modern painting at Vassar in February. The collection show, *Exhibitions of Painting by Modern Masters of Spain, Germany, France, Russia, Italy, Belgium and America (Loaned by Société Anonyme, New York)* took place in the Vassar College Art Gallery, April 4–May 12, 1923, and had a checklist printed by the Vassar College Gallery. The Kandinsky show of six large oil paintings and nine watercolors took place in November. The Société Anonyme booklet, *Kandinsky*, with an essay by Dreier, printed on the occasion of the Société Anonyme exhibition in its New York gallery in April 1923, accompanied the show and served as its catalogue. Correspondence regarding the exhibitions (and the exhibition for Modern Language Week in 1927) is found in the Société Anonyme archives at the Beinecke Rare Book and Manuscript Library, Katherine S. Dreier Papers/Société Anonyme Archive, YCAL MSS 101, box 35, fols. 1040–41 and box 89, fol. 2304. Oliver Tonks lectured on the occasion of each of the exhibitions and *The Vassar Miscellany News* covered both lectures: "Traces Evolution of Modern Painting," *Vassar Miscellany News*, April 21, 1923, 3, and "Modernist Movement in Painting Outlined," *Vassar Miscellany News*, November 7, 1923, 1 and 6.

5. J. C., "Kandinsky Discussed," *Vassar Miscellany News*, November 14, 1923, 2.

6. For Modern Language Week at Vassar, an "Exhibition of Modern European Art" took place April 8–28, 1927. Loans came from Dudensing, de Hauke, Kraushaar, J. B. Neumann, Société Anonyme, M. Sterner, Wildenstein, and E. Weyhe. Walter Pach lectured on "The Classical Element in Modern Art," on April 19, 1927.

7. Panofsky's lecture "What is Baroque?" was given on May 3, 1935, and has been published as part of the collection *Three Essays on Style*, ed. Irving Lavin (Cambridge: MIT Press, 1997). *The Vassar Miscellany News* covered the lecture in a long, unsigned article, "Prof. Panofsky Lectures Here About Baroque. Comparison with Mannerism Made; Explains Parallelism in Drama and Literature; Machines Replace Baroque; Baroque Period is the Second Great Climax of the High Renaissance," *Vassar Miscellany News*, May 8, 1935, 1 and 7 (see fig. 3a, b above).

8. Le Corbusier spoke on November 1, 1935. *The Vassar Miscellany News* covered the lecture in two articles in its November 6 issue: "Modern Housing Text of Lecture by Le Corbusier; Illustrates His Speech with Drawings; Movies of Houses Already Built in Europe; Advocates Simple Utility; Present Made of Life Too Wasteful to Endure in Age of Machine," 1 and 4, and "Le Corbusier Gives Opinions on Mussolini, Vassar, N.Y.C.," 1 and 3. This was part of a tour of the United States by Le Corbusier, which he wrote about at length in his book *Quand les cathédrales étaient blanches: voyage au pays des timides* (Paris: Plon, 1937; see fig. 4 above). The entire tour has been given a fine study by Mardges Bacon in her book *Le Corbusier in America: Travels in the Land of the Timid* (Cambridge: MIT Press, 2001).

9. The relationship between the Art Department and the Museum of Modern Art was personal as well as professional. For a vivid and detailed account that sees the matter through the work of John McAndrew, see Mardges Bacon's forthcoming book, *John McAndrew's Modernist Vision: From the Vassar College Art Library to the Museum of Modern Art in New York.*

10. He reworked the lecture for publication as "Velásquez' *Las Meninas,*" *October* 19 (Winter 1981): 45–54.

11. "A Statement on the Place of the History of Art in the Liberal Arts Curriculum," by a Committee of the College Art Association, *College Art Journal* 3 (March 1944): 84.

12. *College Art Journal* 3 (March 1944): 84.

13. *Grain Vapor Ray*, a publication of the Anthropocene Project at the Haus der Kulturen der Welt, Berlin, ed. Katrin Klingan, Ashkan Sepahvand, Christoph Rosol, and Bernd Sherer (Cambridge: MIT Press, 2014). The meeting for the Anthropocene Project took place at the Haus der Kulturen der Welt on the weekend of October 16–18, 2014. *A Matter Theater* was part of the program for the meeting, as was an exhibition curated by Anselm Franke.

14. Naomi Oreskes gave a précis of her keynote address, "Man as a Geological Agent," in the program book for *The Anthropocene Project: A Report*, 51; see www.hkw.de/media/en/texte/pdf/2014_1/ein_bericht_guide_zum_programm.pdf (accessed August 28, 2015).

15. Robert Horvitz, "A Talk with George Kubler," *Artforum* (October 1973): 34.

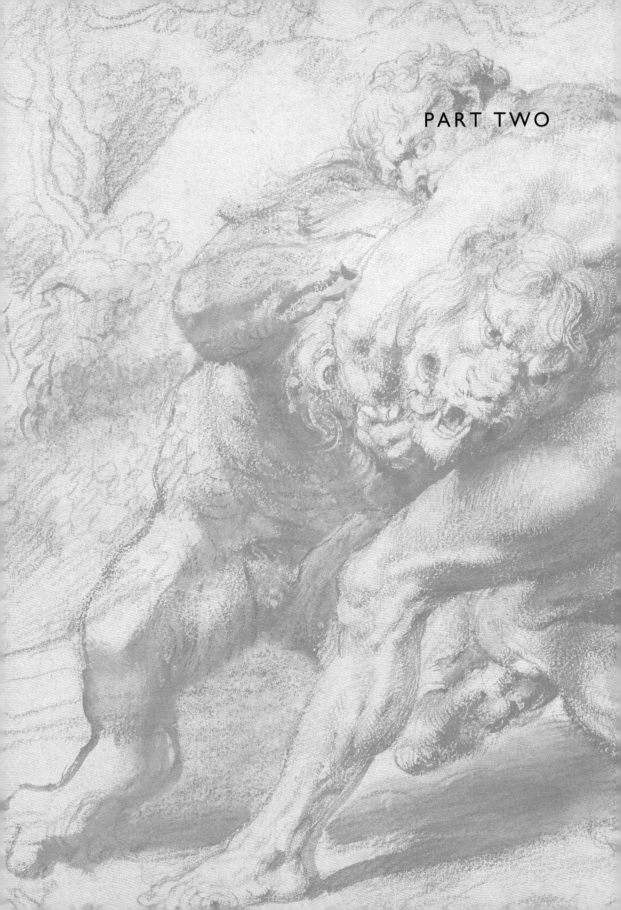

PART TWO

Quixotic Projects: Humanities Research and Public Funding in the United Kingdom

Caroline Arscott

In the context of the professional stratification of late Victorian society there was increasing unease in response to those scholars who wished to make large claims beyond their particular professional field. A physicist could set down findings about the properties of inorganic matter, but if he or she were to pursue the arguments into the life sciences, or into the realm of psychology and ethics, it was liable to spark opposition. The effort to police disciplinary demarcations was in part a defensive action on the part of deists against what appeared to be a creeping materialism that threated to reduce the mysteries of life and the province of God's action to the bouncing of molecules.

It was all very well to discuss the bouncing of molecules when seeking an explanation for the blue color of the sky, or re-creating blue Italian skies in vessels in the laboratory as the British physicist John Tyndall (1820–1893) did from 1868 (fig. 1).[1] He published his findings in the *Philosophical Transactions of the Royal Society of London* in 1870 and described his procedure to a broader audience in his American lectures on light given in 1872–73.

> But we have it in our power to imitate far more closely the natural conditions of this problem. We can generate in air artificial skies, and prove their perfect identity with the natural one, as regards the exhibition of a number of wholly unexpected phenomena. It has been recently shown in a great number of instances by myself that waves of ether issuing from a strong source, such as the sun or the electric light, are competent to shake asunder the atoms of gaseous molecules. . . . It is possible to make the particles of this actinic cloud grow from an infinitesimal and altogether ultra-microscopic size to particles of sensible magnitude; and by means of these in a certain stage of their growth, we produce a blue which rivals, if it does not transcend, that of the deepest and purest Italian sky.[2]

To push the arguments further, as Tyndall went on to do from the mid-1870s, was to provoke a rearguard defense of the traditional territories in which

OF HIGH REFRANGIBILITY UPON GASEOUS MATTER. 337

acid in succession. Thus purified it enters the flask F and bubbles through the liquid.
Charged with vapour it finally passes into the experimental tube, where it is submitted

Fig. 1.

to examination. The electric lamp L placed at the end of the experimental tube furnished
the necessary beam.

Fig. 1. John Tyndall, "On the Action of Rays of High Refrangibility upon Gaseous Matter," *Philosophical Transactions of the Royal Society of London* 160 (1870): 337, fig. 1 (Image downloaded from http://www.jstor.org/stable/109065?pq-origsite=summon&seq=5#page_scan_tab_contents)

leadership of intellectual life had been carried out. The areas of the law, language, history, arts, and theology that had held sway were not considered to be legitimate fields for scientific forms of explanation; in other words, forms of understanding that rested on measurement, experiment, and empirical verification. Cause and effect could not be tracked in the same way, it was argued, on either side of the big divide between matter and life.[3] Certain figures aimed to bridge that gulf, notably a handful of scientists who wished to extend the reach and authority of science and to prevent its containment behind a disciplinary wall as junior newcomer with limited capabilities.

One way of viewing the outcome is that rather than breaking down the wall, as some of them were trying to do, they managed to shift it sideways so that a lesser enclosure, and a gradually diminishing enclosure, was made for the humani-

ties, and that this has persisted into the present day. We could say that current public policies regarding research funding, on both sides of the Atlantic, represent a continuation of that process rather than a sudden switch. Where diminished funding is allocated to the humanities in favor of STEM subjects (science, technology, engineering, mathematics), as in our recent experience, a judgment is being made about priorities, and assumptions are being made about the effects that flow from study and research in those areas. Science is taken to be the boss partner with real findings and concrete benefits for industry and society; the humanities a subaltern subject area where speculation, imagination, and creativity are acknowledged and exercised to questionable effect. The pursuit of practical knowledge is set up against the quixotic projects undertaken in the humanities.

In the United Kingdom a system is in place whereby university researchers can lodge claims about the effects that flow from research, whether in the sciences or in the humanities. The roughly five-year cycle of governmental audit of research in the publicly funded university system relies on submissions made by each unit of assessment, typically a college or a department within a college.[4] This is a competitive system; funding is allocated most generously to the institutions that receive the highest scores in the exercise (though the final funding amount and formula are not announced until the exercise has been completed). For those institutions scoring highly, the proportion of public funding directly linked to this exercise is considerable. It can represent as much as one-third of the public funds flowing into a university, and so the stakes are extremely high. Huge amounts of energy and ingenuity go into each department's return—arguably too much and to the detriment of work directed "naively" at the pressing issues of the disciplines and the furtherance of knowledge. Academic hiring policy is shaped by consideration of performance at the next assessment, and there is even a market in academics who switch institutions late in the day so that their outputs can be secured for another university. Perhaps most worryingly, subtle pressure is exerted against freely sharing thought processes and research directions as each institution seeks to gain credit for its own findings.

Each department chooses the strongest publications or outputs for each of its scholars, up to a maximum of four per person, and the publications are assessed by panels of academics in the relevant field. Universities go through a process of attaching standardized labels with the proper codes printed onto them, wrapping up parcels of books and exhibition dossiers, consigning them to the Royal Mail to go to the Higher Education Funding Council warehouse to arrive on a

stipulated day. Then for a full year the publications are considered by a selection of academics in the field. This peer-review assessment of research is based on the outputs themselves as read or registered by the panels of academics. In many ways, this aspect of the audit is admirable and fairly robust. No metrics are, so far, applied in the humanities, no citation count or journal scoring comes into play. In line with policy articulated by Research Institutes in the History of Art (RIHA), most humanities scholars in the UK do not think that an article that appears in established, high-status journal X is necessarily superior or more important than an article appearing in newly founded, or lesser-known, journal Y.[5] The specter of mechanizing this process by relying on citation counts or an ossified hierarchy of journals is one that makes humanities researchers nervous looking ahead, because such changes have been suggested. Humanities researchers are very thankful to have retained the peer-review process for the time being. Though it is recognized within the universities that peer review is an imperfect process, it remains the best among the options suggested, if research performance is to be quantified.

Alongside this element of peer review of published outputs, two other factors are considered. The first relates to research environment and requires evidence to be presented relating to the infrastructure, quality control, and opportunities provided by the institution for its researchers (from academic staff to research students) and the service to the academic community of its researchers. The second is a new factor, introduced in the most recent 2014 audit exercise and the one that is most relevant in the context of the Clark Art Institute's "Art History and Emergency" conference: this is the measurement of Impact beyond the academic sphere. Each department (or unit of assessment) has to provide a summary of the benefits, beyond academia, that can be shown to be caused by the research undertaken there. In addition, individual projects or activities have to be presented in detail as case studies showing just what verifiable benefits have accrued.

The introduction of a measurement of Impact is a direct consequence of the political argument that public funds should go only to activities able to show public benefit. It emerges within an overall rhetoric of austerity; in an adverse economic climate, a cost-benefit analysis has to be undertaken to show that expenditure is not wasteful. Social and economic benefits are demonstrable and to some extent quantifiable where particular research projects develop a technological solution to increase egg production or speed up and improve performance of electric motors.[7] The investment in the research undertaken within universities is justifiable if it delivers the goods on this model. If it cannot be shown to do

so, then the activities should be considered as unimportant luxuries, at best, or a larcenous embezzlement of public money, at worst. Enthusiasm for this argument has brought out a vein of sneering anti-intellectualism in government.

For individual humanities departments it is dangled as a lifeline against the wholesale downgrading of the humanities. There may be a shift in the funding formula to the disadvantage of the humanities, but the most impactful humanities research will not be set aside as wasteful. And every humanities department makes a grab for the lifeline and pursues Impact exactly in the way that science departments do. The diagram displayed on the Glasgow University website for actions to be taken within a medical/veterinary school (fig. 2) gives a very accurate picture of actions taken in art history departments. If you have a media darling in a department, you can construct an argument to show that your research is having Impact on the hundreds of thousands of viewers of television history programs. Public engagement has moved up to the top of the agenda. Links with businesses from manufacturing to tourism have been initiated. Academics in the United Kingdom just cannot afford to spend the same proportion of their time in the library or seminar room anymore, pursuing intellectual exploration and exchange. Art

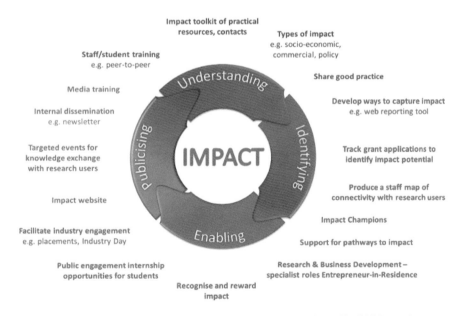

Fig. 2. University of Glasgow, College of Medical, Veterinary and Life Sciences, "Impact Tool Kit" (image downloaded from http://www.gla.ac.uk/colleges/mvls/researchimpact/ourstrategy)

history arguably has a head start in this new challenge to show Impact because exhibition activities and collaborations with public museums and engagement with world heritage have always been important strands of our research; but the basis of this is a competition for points, and there will inevitably be an Impact inflation as my Westminster Abbey with five hundred take-ups of podcasts trumps your Canterbury Cathedral with eighty teacher guides. Academics have to jockey to get in on the big exhibition spaces and badger museums and broadcasting companies for footfall and exhibition sales statistics, website hits, scans of visitor books, viewer figures, fees earned for worldwide retransmission, fees earned for connections with tour companies, etc.

In answer to those who say this is our opportunity to make a case for the humanities and that if we really believe in their value, we should be able to express what the value is, I would point out that it is very difficult to quantify and provide auditable evidence trails for the generic public benefits of the humanities. We may with mixed success seek to identify and provide evidence of points of knowledge exchange or transmission of research findings. It is less easy to show what Impact the knowledge has on those accessing it. Rare is the entry in a visitor book that says, "This helps me understand who I am and what role I may play in the world," or "This gives me a handle on the despair that I have felt." In my lifetime, art historical research has produced arguments about the canon in terms of gender, sexuality, and geographies; the investigations of the role of materials in generating meaning; the relativizing of aesthetic positions formerly considered absolute—all of these have revolutionized the relationship that viewers, users, and makers can have with art and elements of visual culture. Demystified and historicized, globalized, democratized, decoded, and accorded revised respect, art and an understanding of aspects of the history of art now play a more important and humane role than ever in society. These are social benefits of academic research, but departments cannot claim a single audit point from them because this major ongoing intellectual project has been a collective and gradual one.

The physicist John Tyndall was berated for straying from his proper realm of heat, force, and matter; and turning key projects such as the relationship between optics and diffused gases into "wild theories" about life and death, "the formation of the universe, and the origin of species." His notorious Belfast Address, given at the annual gathering of scientists convened by the British Association in 1874, caused a furor.[8] Undaunted, he took every opportunity over the next decade to propound his vision of intellectual culture refreshed by the ingress of science

and the dislodging of theology. John Tyndall can be regarded as a figure who sought to take the perspectives emerging from new fields of science into the territory of the humanities to knock down the wall between the two. The arguments he sought to make were not based on a characterization of science as restricted to fact and empirical findings. Rather, he saw science as a model for inquiry precisely because it combined the verifiable with the speculative. Blue skies characterized his methods as well as his research topic. Tyndall argued that, in the process of dislodging dogmatic theology, science would have to face up to the inexplicable in nature: the mystery of life and consciousness, the awesome in nature—he believed that this perspective acted as a productive stimulus within the laboratory.

I suggest that rather than fight our corner within the beleaguered humanities and rather than focus excessively on generating measurable public engagement, treating exhibitions and websites as if they were egg-production facilities, we should seek common ground with the less instrumental aspects of the sciences. In the debate over research funding in the UK, the auditing of Impact has caused great anxiety within the sciences as well as the humanities because it favors predictable projects with immediate payoffs over blue-skies thinking. In art history we might say we have a track record of according prime place to blue skies, whether studying Giotto, Yves Klein, or Tacita Dean. Many of our projects are perhaps quixotic, tainted by book learning, cut loose from practical considerations, not instrumentally linked to economic productiveness. But we should remember that Don Quixote, leading character in the 1605 novel of Cervantes, was not just a figure of fun—he was a channel for social critique. The Victorian novelist George Eliot invoked Don Quixote in the fictional person of Casaubon in *Middlemarch*, published in 1871–72. Casaubon was drawn as ridiculous and repulsive, mired in an ever-elaborated and unfinishable academic project foolishly attempting an overbroad remit; Eliot quotes Cervantes at the chapter heading when Casaubon comes into focus.[9] But by 1876, she had reversed this formulation in her novel *Daniel Deronda*, which celebrates the breadth of vision of the studious and intensely driven Mordecai, standing on the bridge over the Thames, in the "saffron clearness" of the evening light, listening, as he said, "to the messages of earth and sky," alert to the currents of history and the possibilities of the future, able to envisage a unifying theory for the human race.[10] This is the version of the quixotic that has some resonance for academic research. As art historians, we cannot allow ourselves to turn our backs on clear skies despite the pressures of narrow cost-benefit thinking.

1. Götz Hoeppe, *Blau: Die Farbe des Himmels* (Heidelberg: Elsivier GmbH, Spektrum, Akademische Verlag, 1999); trans. with John Stewart, *Why the Sky is Blue: Discovering the Color of Life* (Princeton: Princeton University Press, 2007), 159–65.

2. John Tyndall, "On the Action of Rays of High Refrangibility upon Gaseous Matter," *Philosophical Transactions of the Royal Society of London* 160 (1870): 333–65; John Tyndall, *Six Lectures on Light: Delivered in America in 1872–1873* (London: Longmans Green and Co., 1875), 157.

3. Stephen Collini, *Public Moralists: Political Thought and Intellectual Life in Britain, 1850–1930* (Oxford: Clarendon Press, 1991), 203–5. See also Ursula DeYoung, *A Vision of Modern Science: John Tyndall and the Role of the Scientist in Victorian Culture* (New York: Palgrave Macmillan, 2011).

4. Most recently, "Research Excellence Framework 2014" conducted by Higher Education Funding Councils for Great Britain. Full details published at http://www.ref.ac.uk/ (accessed July 1, 2015). REF 2014 assessed the work of roughly 50,000 researchers in over 150 institutions of higher education: http://www.theguardian.com/higher-education-network/2014/dec/17/ref-2014-why-is-it-such-a-big-deal. The initial funding allocation from REF 2014 was outlined by Higher Education Funding Council for England in February 2015, http://www.hefce.ac.uk/pubs/year/2015/CL,032015/ (accessed July 1, 2015).

5. RIHA policy statements published at http://www.riha-institutes.org/Resolutions.aspx (accessed July 1, 2015).

6. The Higher Education Policy Institute published thoughtful remarks on the introduction of Impact: see Bahram Bekhradnia, "Proposals for the Research Excellence Framework: A Critique," Report 43, October 15, 2009, http://www.hepi.ac.uk/2009/10/15/proposals-for-the-research-excellence-framework-a-critique (accessed July 1, 2015).

7. These examples are taken from the University of Glasgow research Impact webpage, http://www.gla.ac.uk/research/impact/impactsontheeconomybusinessandinnovation (accessed July 1, 2015).

8. John Tyndall, *Address Delivered before the British Association Assembled at Belfast, Revised by the Author* (New York: D. Appleton & Co., 1875). The quotations are from a sermon by Rev. John MacNaughtan, quoted by Ursula DeYoung, *A Vision of Modern Science*, 117. Also see John MacNaughtan, *The Address of Professor Tyndall at the Opening of the British Association for the Advancement of Science, Examined in a Sermon on Christianity and Science* (Belfast: C. Aitchison, 1874), 8–9. For further discussion of reactions to the Belfast Address, see Frank M. Turner, *Contesting Cultural Authority* (Cambridge: Cambridge University Press, 1993), 262–83; Bernard Lightman, "Scientists as Materialists in the Periodical Press: Tyndall's Belfast Address," in *Science Serialized: Representation of the Sciences in Nineteenth-century Periodicals*, ed. Geoffrey Cantor and Sally Shuttleworth, Dibner Institute Studies in the History of Science and Technology (Cambridge: MIT Press, 2004), 199–237; DeYoung, *A Vision of Modern Science*, 89–130.

9. "'Seest thou not yon cavalier that cometh toward us on a dapple-gray steed, and weareth a golden

helmet?' 'What I see,' answered Sancho, 'is nothing but a man on a gray ass like my own, who carries something shiny on his head.' 'Just so,' answered Don Quixote: 'and that resplendent object is the helmet of Mambrino.'"

"'SIR HUMPHRY DAVY?' said Mr. Brooke, over the soup, in his easy smiling way, taking up Sir James Chettam's remark that he was studying Davy's Agricultural Chemistry. . . . Dorothea felt a little more uneasy than usual. In the beginning of dinner, the party being small and the room still, these motes from the mass of a magistrate's mind fell too noticeably. She wondered how a man like Mr. Casaubon would support such triviality"; quoted from George Eliot, *Middlemarch*, in parts 1871–2 (Edinburgh and London: Blackwood, 1871), vol. 1, chap. 2, 17. Chester Mills, "Eliot's Casaubon: The Quixotic in *Middlemarch*," in *The Cervantean Heritage; Reception and Influence of Cervantes in Britain*, ed. J.A.G. Ardila (London: Modern Humanities Research Association and Maney Publishing, 2009), 176–80.

10. George Eliot, *Daniel Deronda*, in parts 1874–6 (Edinburgh and London: Blackwood, 1876), vol. 3, book 5, "Mordecai," 169–70.

The Language of Art: A Saving Power?

Anatoli Mikhailov

I was struck and at the same time inspired by the topic of our conference. Let us recognize that the word "emergency" is not very common for this kind of disciplinary conference, particularly those dealing with such issues as art and art history. We know that traditionally this word is used mainly in a different social and political context. We live, however, in a very troubled world. Still, our attempts to solve the urgent issues that *emerge* in each case are too often connected with naïve expectations—looking for immediate solutions—while at the same time they demonstrate our *inability* to address the basic issues of our presence in the world and the causes of these emerging problems.

This diagnosis was formulated by Hannah Arendt as early as the middle of the last century: "the human mind had ceased, for some mysterious reasons, to function properly . . ."; modern man "had come to live in a world in which his mind and his tradition of thought were not even capable of asking adequate, meaningful questions, let alone of giving answers to its own perplexities."[1] Despite optimistic and even euphoric expectations after the end of the Cold War, it is time to recognize that our world is entering a new phase of crisis: it encompasses the rise of ethnic and religious tensions, growing threats of terrorism, deepening economic and financial problems, unhealthy encroachments on the environment, the spread of unexpected diseases, and recent conflict between Russia and the West.

The talk about crisis is not new. The whole twentieth century was full of apocalyptic predictions by philosophers, artists, writers, and even scientists. Edmund Husserl, founder of the phenomenological movement, had proclaimed at the beginning of his career his desire to convert philosophy into a "rigorous science"; however, in his last, posthumously published, book, he reflected on the phenomenon that he designated the "Crisis of European Sciences."[2] He certainly understood that he was raising this issue in a time of unprecedented achievements in the sciences and was not attempting to question them. Rather, the problem he addressed was connected with the danger of domination in twentieth-century culture of a mode of thought based on abstract principles and formulated in a language that alienated the individual from the *Lebenswelt* (literally, life-world; life as seen through a person's subjective experience). The concern about the scope of

the crisis was so profound that Martin Heidegger, commonly regarded as the most influential philosopher of the twentieth century, summarized his perception of it in an interview, destined to be published only after his death, with the dramatic statement: "Only a God can still save us."[3]

One of the consequences of this crisis is that in recent decades the humanities and the arts have been undergoing a dramatic reevaluation regarding their nature and place in society. They are becoming increasingly marginalized and are trying, without much success, to preserve their place in society through continuing their creative lives in isolated and highly specialized professional ghettos. Efforts to address the problem through a "crisis management" framework fail to recognize that too often the remedy is sought, willingly or unwillingly, through the same means that have caused the crisis. Arendt formulated her concern in a strikingly impressive way: "thought and reality have parted company."[4] This diagnosis means that our dominant way of addressing emergent problems too often occurs as abstract reflection that has little relation to the reality in which we live. Such thought is based on theoretical reasoning that implements the language of concepts and ignores art as a different way of revealing reality. It also implies that at the present stage of societal development in the age of globalization, with all our technological achievements, we have lost the ability to properly address the question of the meaning of our lives. In exile in the United States in 1951, Arendt had this to say: America's passion—to make the world a better place to live in—has had as a consequence that in the process of this world improvement, all have forgotten what it means to live. "Americans now find themselves really in one of the 'best of all possible worlds' and have lost *life* itself. It *is* a hell."[5]

The way the work of art is addressed, particularly in the second half of the twentieth century, indicates a new approach toward the language of art and its power to influence the nature of our perception of the world and all our behavior. Interpreted as a challenge to the hegemony of conceptual thinking, it presents itself as an alternative approach to the world. In this case, art becomes not a matter of the special discipline of "aesthetics" or of studies under the traditional title "art history," but is perceived as a new and more productive kind of human experience. Such thinking stems from recognition of the limitations of science with its tendency to focus on the particular and factual reality. But it is not only the "scientific" approach that reduces the human experience to a certain kind of "knowledge" measured through the paradigm of science. The whole Western intellectual tradition has increasingly been relying on principles that conceal the

nature of things. This was the main thrust of the phenomenological principle proclaimed by Husserl at the beginning of the twentieth century—"*back to the things themselves*"—and an attempt of Heidegger in his early work to rediscover "*factual* life." It is here that the issue of the nature of art and its place in our lives becomes a focal point of various, often very dramatic, discussions, which take place in the context of careful re-readings of the previous dominant understanding of the nature of art. Hegel's statement about art in his *Lectures on Aesthetics* is well known and is worth remembering because it summarizes the essence of roughly 2,500 years of the Western intellectual tradition, starting from Plato:

> But while on the one hand we give this high position to art, it is on the other hand just as necessary to remember that neither in content nor in form is art the highest and absolute mode of bringing to our minds the true interests of the spirit. . . . However all this may be, it is certainly the case that art no longer affords that satisfaction of spiritual needs which earlier ages and nations sought in it, and found in it alone. . . . In all these respects art, considered in its highest vocation, is and remains for us a thing of the past. . . . For us art counts no longer as the highest mode in which truth fashions an existence for itself. . . . We may well hope that art will always rise higher and come to perfection, but the form of art has ceased to be the supreme need of the spirit."[6]

H.-G. Gadamer: The Work of Art between Word and Image

According to Hans-Georg Gadamer, art is traditionally perceived as merely one of the pleasures that either satisfies ordinary sensibilities or belongs to the sphere of refined education and research. In both cases, we are dealing with expediency and the utility of artworks.

Still, research in art history remains too heavily under the pressure of disciplinary norms that become the subject of interest to a highly specialized professional community. Although the value of such research must be recognized, research does not fully address the purpose of a work of art, which is *to help us to see things differently.* To do this, we need to depart from particular traditions of conceptual thought and try to look at the world outside of prevailing clichés. We can then experience the wonder and surprise that accompany the immediate experience of an artwork, thereby enlarging our horizons and contributing to our development as human beings. We must encounter the work through *personal ex-*

perience. Gadamer acknowledges that scholarly research generally fails to preserve the vivid *presentness* and contemporaneousness of art that constitute and maintain its power. He finds something repellent in the very idea that art, which possesses such a captivating presentness, could become a mere object of historical research, because such objectification ignores art's superiority over time, a superiority that defies all restrictions. Art history thus has become a discipline that treats the work of art as an object of theoretical reflection, but the very nature of the work of art disappears.

What we are talking about here is not intended to undermine the importance of scientific research. But, as Gadamer maintains, the kind of knowing in science remains, as such, quite different from experiencing the presentness of art. We do not rediscover the power and attractiveness of a work of art through the intensiveness of research, which, by the way, is witnessing more and more substantive limitations in the present technological era where the work of art increasingly has become a commodity. The question arises whether in the time of "machination" (Heidegger) and "reproducibility" (Walter Benjamin) we are still able to address the issue of the importance of art for humanity. In too many cases it becomes simply a matter of defending the professional status and interests of those who are dealing with art and promoting it. What are the reasons to believe that the traditional activities of addressing art in the framework of art criticism or research in art history can be continued and, for instance, that conferences such as this one will be funded in the future? Don't we belong to the kind of species that are put more and more at the periphery of the mainstream development dictated by technology? May we therefore address this issue in the framework of the more dramatic terms formulated by Nietzsche: "Our salvation does not lie in *knowing*, but in *creating*." Speaking about global challenges in the twenty-first century, however, we need to recognize that some lessons of the previous century—when the issue of crisis of our thought was raised in sufficiently alarming terms—have still not been properly learned. It is clear that in order to talk about the crisis, we must recognize that our basic mindset is at its root.

Almost two-thirds of Gadamer's book *Truth and Method* is devoted to his attempts to address the idea of the *nature of experience* of the work of art. Its first main section is entitled "Uncovering the Question of Truth in the Experience of Art"; the last subsection of this portion is called "The Ontology of the Work of Art and Its Hermeneutical Significance." Gadamer returns to the roots of the still-dominant perception of the nature of art as reinforced by Kant in his

Third Critique. According to Kant, aesthetic experience lies completely in human subjectivity and therefore does not constitute the object. This means that art is denied "any claim to being a significant form of cognition" and the work of art is denied any claim to truth. It is in this context that Gadamer raises the issue of getting knowledge through art:

> Does not the experience of art contain a claim to truth which is certainly different from that of science, but just as certainly is not inferior to it? And is not the task of aesthetics precisely to ground the fact that the experience (Erfahrung) of art is a mode of knowledge of a unique kind, certainly different from that sensory knowledge which provides science with the ultimate data from which it constructs the knowledge of nature, and certainly different from all moral rational knowledge, and indeed from all conceptual knowledge—but still knowledge, i.e., conveying truth?[7]

Gadamer emphasizes the danger that a work of art from the past or from a different culture that is transferred into our educated world may become a mere object of enjoyment or aesthetic-historical research. In this context, he raises the question whether a work of art has to say something meaningful and important for our own lives. He proposes to transform the systematic problem of *aesthetics* into the question of the *experience* of *art.*[8] This idea is the result of a very careful reading and interpretation of Heidegger's *The Origin of the Work of Art*, completed in 1935, but not published until 1950. The main question of this publication is whether the work of art helps to generate a kind of thinking that is *different* from the dominant language of conceptual thought with its presumed absolute authority of *logos.*

We must be aware of the extreme difficulty of the task of rethinking the language issue because it takes place too often within the boundaries of the same language and therefore forecloses its very results.

In the final part of *Truth and Method*, Gadamer traces the origin of the idea of language in Plato's dialogue *Cratylos*. In this chapter, "The Development of the Concept of Language in the History of Western Thought," he notes that "in all discussion of language ever since, the concept of image . . . has been replaced by that of sign."[9] In his view, it is "the first step toward modern instrumental theory of language. . . . Wedged in between image and sign, the being of language could only be reduced to the level of pure sign."[10]

Against this abstract understanding of language use, he addresses the issue of the language of art as a *revelatory power* that appeals to us without articulating any kind of conceptuality. Therefore, the expressiveness of art makes it possible to experience the world differently from the theoretical contemplation of objects of external experience. When we are caught in the dominant framework of conceptuality, we block the very perception of the work of art. As a result, as Heidegger writes, "We force the work into a preconceived framework by which we obstruct our own access to the work-being of the work. . . . To gain access to the work, it would be necessary to remove it from all relations to something other than itself, in order to let it stand on its own for itself alone."[11]

Is such an experience really achievable in our present world, which seems not only not to be promoting our grasp of the artwork but also contributing to various obstructions of it?

Our reality, according to Heidegger, is that

> the works themselves stand and hang in collections and exhibitions. But are they here in themselves as the works they themselves are, or are they not rather here as objects of the art industry? Works are made available for public and private art appreciation. Official agencies assume the care and maintenance of works. Connoisseurs and critics busy themselves with them. Art dealers supply the market. Art-historical study makes the works the objects of a science. Yet in all this busy activity do we encounter the work itself?[12]

This conclusion indicates a dramatic change of the *place* of a work of art—which should rather be identified as "displacement." For Heidegger, it is exactly the *place* that constitutes the very nature of a work of art. "The work belongs, as work, uniquely within the realm that is opened up by itself."[13]

> The Aegina sculptures in the Munich collection, Sophocles' *Antigone* in the best critical editon, are, as the works they are, torn out of their own native sphere. However high their quality and power of impression, however good their state of preservation, however certain their interpretation, placing them in a collection has withdrawn them from their own world. But even if we make an effort to cancel or avoid such displacement of works—when, for instance, we visit the temple in

Paestum at its own site or the Bamberg cathedral on its own square—
the world of the work that stands there has perished.[14]

No doubt, Heidegger was well aware of the impossibility of reestablishing a time not influenced by technology and its consequences that resulted in "world-with-drawal" and "world-decay," which, he said, "can never be undone." At the same time, his expressed view that art possesses a "saving power" is very radical. In the time of nihilism (Nietzsche) and of the domination of technology, one of the most destructive consequences is our experience of language: perceived as a domain of pure significations, it has presupposed and guaranteed the possibility and stability of meaning. As Nietzsche wrote in *On Truth and Lies in a Nonmoral Sense*: "It is this way with all of us concerning language; we believe that we know something about the things themselves when we speak of trees, colors, snow, and flowers; and yet we possess nothing but metaphors for things—metaphors which correspond in no way to the original entities."[15]

We live, however, in a time when what Heidegger says of philosophy—where "all essential titles have become impossible because all fundamental words have been used up and the genuine relation to the word has been destroyed"[16]—is becoming a real threat to humanity. In a time of language degradation and of its inability to transfer vitality to meaning, the work of art with its potential to name things by their own names can carry a saving power. As Hölderlin expressed it in his hymn *Patmos*: "But where danger threatens / That which saves from it also grows."[17] In this case, however, language has the potential of forming us through bringing entities *into being* instead of merely referring to them in a fixed way of signification. Through such "language," as Dennis Schmidt notes in his remarkable book, we perceive art as "an event of being, a birth into the world."[18]

Here we encounter a link with a new connotation of the conference title's word "emergency," which emphasizes a new approach to the nature of a work of art connected with the meaning implied by "emerge." "There is a sort of birth or, to use Klee's language, a genesis proper to the work of art," writes Schmidt. "This is, in part, what Heidegger means when he speaks of art as an 'origin' and a 'bringing forth.' This movement, this *emergence* [author's emphasis] that is the event of being, most defines the nature of a work of art."[19]

Therefore, what Heidegger appreciates in paintings of Klee, Cézanne,

and Van Gogh is not something placed in them as representative of something else. It is

> *movement, the movement of life itself.* Painting here is seen to be a matter of becoming, of infinitive genesis, of birth. It is a *free* motion without reference to cause, without concern for a 'why,' and without letting this motion come to rest in a finished form, that is, in an object that has been represented. It is not the object as such that is presented but the coming into being of a world, the presentation itself, that is presented.[20]

Such an approach to art within the discipline of art history requires radical revision of the way of thinking that is deeply engraved in Western intellectual tradition. In no way does it indicate a mere change of paradigms or a switch to another language. This kind of "language," which is so powerfully present in a work of art—the language perceived as "a combination of flesh and spirit" (Paul Valéry)—has yet to "emerge" as our existential response to the needs of our time.[21]

The Present Reality

We live in a time when we must recognize that our traditional ways of doing research and teaching in the field of art history should be changed to promote an understanding of the nature of art that reaches far beyond its disciplinary place within academia—a place that is becoming increasingly fragile.

A recent survey conducted by Asit Biswas and Julian Kirchherr revealed that every year about 1.5 million articles are being published in data-based journals. However, about 82 percent of those publications in the humanities are never quoted. The conclusion of the survey is pretty sad: *Prof, no one is reading you!*[22] Clearly, the Internet era also has had a profound effect on our ability to preserve intact traditional professional activity in the field of the history of art. It is a time, writes Hubert Dreyfus,

> when we enter cyberspace and leave behind our animal-shaped, emotional, intuitive, situated, vulnerable, embodied selves, and thereby gain a remarkable new freedom never before available to human beings, we might, at the same time, necessarily lose some of our crucial capacities: our ability to make sense of things so as to distinguish the relevant from

the irrelevant, our sense of the seriousness of success and failure that is necessary for learning, and our need to get a maximum grip on the world that gives us our sense of the reality of things.[23]

Hannah Arendt's already-mentioned book *Between Past and Future* has as its subtitle *Eight Exercises in Political Thought*, a clear indication that the book discusses political reality in a manner that recognizes the painful failure of traditional ways of theorizing about it. We should also not ignore the existential background of Arendt's reflections, derived from her own drama of exile and the tragedy of her native country, Germany. In the book's preface, Arendt makes numerous references to prominent literary figures Franz Kafka, René Char, William Faulkner, and André Malraux. Such a clear departure from conventional ways of addressing political reality in the context of her clarification of the issue *how to think* is accompanied elsewhere by her suggestion that Kant's last *Critique*, usually interpreted almost exclusively as dealing with beauty and the sublime, can be regarded as a new paradigm of political theory. This is another example that the language of art is much more powerful for our thinking about the world we live in than we have traditionally believed. Such thoughtful insights still remain enigmatic for those who prefer to stay within the boundaries of a conservative disciplinary approach to art and its history.

———

My own experience of personal involvement in the establishment of an institution is with the European Humanities University, where something previously nonexistent but vitally important for the transformation of a country like Belarus was created after the collapse of the Soviet Union; though it can be regarded as a necessary prerequisite for transformation of our own way of thinking, it is far from being regarded as impressively successful. There is still a lack of proper understanding that a humanities education is crucial for stimulation of creativity, which is not always naturally present in a human being.

For its allegedly subversive activities, the university was brutally closed by the Lukashenko regime in 2004 and is now functioning in exile in Vilnius, Lithuania, trying to secure its survival with very limited support from institutions of the European Union and the United States.[24] At the same time, various programs of a completely abstract nature and having no relationship to factual reality are

being implemented—and there is strong belief in their inevitable success. Challenging these stereotypical thoughts means going far beyond possible constructive assistance only to European Humanities University or a country such as Belarus.

1. Hannah Arendt, *Between Past and Future: Eight Exercises in Political Thought* (New York: Penguin Books, 1977; 1st ed. New York: Viking Press, 1961), 9.

2. "Philosophie als strenge Wissenschaft" (1911 essay); *Die Krisis der europäischen Wissenschaften und die transzendentale Phänomenologie* (Belgrade, 1936). See Edmund Husserl, *The Crisis of European Sciences and Transcendental Phenomenology*, trans. David Carr (Evanston, IL: Northwestern University Press, 1970). See also Edmund Husserl, *Phenomenology and the Crisis of Philosophy*, trans. and with intro. by Quentin Lauer (New York: Harper & Row/Torchbook, 1965); the two translated works in this volume are Husserl's Prague lecture, delivered in 1935, "Philosophy and the Crisis of European Man" (Philosophie und die Krisis der europäischen Menschentums), and the 1911 essay noted above.

3. Interview published in *Der Spiegel*, May 31, 1976, "Nur noch ein Gott kann uns retten." The interview took place on September 23, 1966.

4. Hannah Arendt, *Between Past and Future: Eight Exercises in Political Thought* (New York: Viking Press, 1961), 6.

5. Hannah Arendt, *Denktagebuch, 1950 bis 1973*, vol. 1 (Munich and Zurich: Piper, 2002), 105 (author's translation).

6. Georg Wilhelm Friedrich Hegel, *Aesthetics: Lectures on Fine Art*, trans. T. M. Knox, vol. 1 (Oxford: Clarendon Press, 1975), 9–11, 103.

7. Hans-Georg Gadamer, *Truth and Method*, 2nd rev. ed. (London and New York: Continuum, 2004), 84.

8. Hans-Georg Gadamer, *Philosophical Hermeneutics*, trans. and ed. David E. Linge (Berkeley: University of California Press, 1976), 97.

9. Gadamer, *Truth and Method*, 414.

10. Gadamer, *Truth and Method*, 418.

11. Martin Heidegger, *Poetry, Language, Thought* (New York: Harper and Row, 1975), 40; see also *Philosophies of Art and Beauty: Selected Readings in Aesthetics from Plato to Heidegger*, ed. Albert Hofstadter and Richard Kuhns (Chicago: University of Chicago Press, 1964), 669.

12. Heidegger, *Poetry, Language, Thought*, 40; *Philosophies of Art and Beauty*, 669.

13. Heidegger, *Poetry, Language, Thought*, 41.

14. Heidegger, *Poetry, Language, Thought*, 40–41.

15. Friedrich Nietzsche, "On Truth and Lies in a Nonmoral Sense," in *Philosophy and Truth. Selections from Nietzsche's Notebooks of the early 1870's*, trans. and ed. Daniel Breazeale (Atlantic Highlands: Humanities Press, 1979), 79–91.

16. John Sallis, "The Manic Saying of Being," in *Heideggers "Beiträge zur Philosophie," international colloquium, May 20–22, 2004, held at the University of Lausanne, Switzerland*, ed. Emmanuel Mejia and Ingeborg Schüßler (Frankfurt am Main: Klostermann, 2009), 77–78.

17. Friedrich Hölderlin, *Poems and Fragments*, trans. Michael Hamburger (Cambridge: Cambridge University Press, 1980), 463.

18. Dennis J. Schmidt, *Between Word and Image: Heidegger, Klee, and Gadamer on Gesture and Genesis* (Bloomington: Indiana University Press, 2013), 117.

19. Schmidt, *Between Word and Image*, 117–18.

20. Schmidt, *Between Word and Image*, 92.

21. Paul Valéry, "The Position of Baudelaire," *Variety: Second Series*, trans. William Aspenwall Bradley (New York: Harcourt, Brace and Company, 1938), 93.

22. *Die Zeit*, no. 31, July 30, 2015.

23. Hubert L. Dreyfus, *On the Internet*, 2nd ed. (London and New York: Routledge, 2009), 7.

24. See more in Anatoli Mikhailov, "University in Exile: Experience of the Twenty-First Century," *Social Research: An International Quarterly* 76, no. 3 (Fall 2009), 849–66.

After Scully: Emergency in the Age of Visual Democracy

Mary Miller

For sixty years, undergraduate students at Yale University, when speaking of the art history course that had captured their imaginations, referred not to "History of Art 112" but rather to "Scully," as if it were a brand name rather than a lecture course delivered by Vincent Scully Jr., who retired as Sterling Professor of the History of Art in 1991, and who had been at teaching at Yale for over forty years at that point. Despite official retirement, Scully would teach the survey most years until 2008, and always in the fall semester, rather than the spring, when he could initiate students' study of the visual world with hand-drawn studies they would make on warm September days of the Hewitt Quadrangle (informally known as Beinecke Plaza). As many as five hundred students annually learned to look at the world around them and the world of art inside the Yale University Art Gallery in the course Scully had developed early in his career on the faculty. Scully opened not only students' eyes but also required that they step across the threshold of university museums on a nearly weekly basis. For most of those years he taught in the Law School Auditorium, with students perched in window wells and slouching at the back of the hall; later he would move to the Yale University Art Gallery, where the large-format lantern slides he preferred for their crisp resolution could still be deployed.

Scully began his course each year with a lecture in complete darkness—what he preferred for every class—and two simple words: "The caves," he intoned. He started quietly but quickly moved to a roar, and slide by slide, the caves of Lascaux and Altamira came to life, the running aurochs, bison drawn one atop another; in the dark, the students and their teaching assistants—of which I was one—could see the horses move, each set of legs drawn to show motion distinct from the one before. And Mr. Scully, as we teaching assistants called him, spoke of technique, and the blur that these ancient painters achieved to generate foreshortening. He reminded us that Picasso had said, "we have invented nothing," after seeing the caves at Lascaux.[1]

And so the course began, with Scully imploring students not to take notes, but to be in the moment—what the teaching assistants could see was a moment akin to the invention of cinema, from those first moving horses of the

caves—and to learn to trust the eyes, not just the words that translated the visual experience into exams and papers. Students knew not to fetishize note-taking in class: Scully commanded them to look hard, to understand and experience the works and buildings as he spoke; he insisted that they start with the work itself, and only then read.

But certainly the class was rich with words, a spellbinding narrative from Scully that wove history, line, color, and the very making of art and architecture. Even as the image dominated the text, the two were inseparable, Scully's vision and the vision on the screen.[2] Scully did not raise feminism or colonialism, or studies of race and critical theory, lenses of concern to the teaching assistants, who tried from time to time to introduce such matters into the discussion sections: he had a story to tell, and images to articulate and bring to life, and he established an effective platform for subsequent study. Later on, undergraduates studied the mix of color and black-and-white pictures collected from various sources, from book jackets to purchased photographs, posted along the cathedral-like and sky-lit galleries of Street Hall, now part of the Yale University Art Gallery but then devoted entirely to classrooms, study galleries, and offices of the History of Art department. Most of the discussion sections took place in the Art Gallery, groups of students gathered around Roman sculpture or Quattrocento paintings. For much of the twentieth century, this was a steady state. As long as Scully was on the rostrum, there was no emergency.

There are many histories of the humanities, but let us take a minute to think about their evolution with respect to technology, and to think about how we arrived at the steady state of Scully. Perhaps the earliest forms of the humanities required no more than the human brain, body, and voice: humans invented, recited, and sang poetry, committing sagas and epics to memory. And at the same time, humans across the planet engaged in early philosophical inquiry, often through direct argument and disputation, as students and scholars gathered to understand the nature and meaning of life. From time to time, one scholar or another would write down the texts that have come down to us, but the means of the divulgation of the ideas in their moment was usually the gathering of followers, the discussion, and the argument. Those who would write history or compile knowledge—and here one might think of Thucydides or Pliny or Bartholomeus Anglicus—would have had access to manuscripts and documents, all the purview of the elite or a clerical establishment. Words and texts were equally accessible, and they were equally inaccessible.

The printing press changed many things, but perhaps one of the things we think about the least is that the black-and-white line drawing circulated more fluently alongside and often on the same page as the black-and-white text, whereas before the press, some texts were accompanied by color images, or were themselves color images; the same environment that held unique manuscripts may well have held paintings, tapestries, or other visual materials. As libraries formed, and although generally private or restricted, even in a university setting, their holdings increasingly focused on the printed book, which quickly began to overtake the manuscript in number and in accessibility. Far less valuable than the unique manuscript, the printed book became the default source in which to consult Augustine or Sappho; the more accessible and available the printed word, the less likely it was to include rich visual imagery. Although luxury folios were printed as well, with color added by hand, these were the rarities, with some broader dissemination after the widespread introduction of lithography in the nineteenth century.

Inexpensive wood-pulp paper changed everything. Books could be printed cheaply and disseminated widely in the post–Civil War era in the United States, when land grant colleges and many liberal arts colleges—Smith, Wellesley, and Swarthmore Colleges, among them—were founded. The book on pulp paper could be obtained by anyone, whether engaged in higher education or not, especially after Andrew Carnegie's initiative to establish public libraries across the United States, starting in 1883. If a student was assigned Jane Austen or Plato to read, there were dozens of editions to purchase; libraries in cities, towns, schools, colleges, and universities stocked multiple copies; used copies were handed down across generations and shared among families. Little wonder that literature and philosophy became king in the American educational system. These inexpensive editions created their own emergency, printed on acidic paper that turned to dust within a few decades, and that by virtue of their very inexpensive production, were less likely to include images of any sort. Where was art?

Until relatively recently in the history of humanity and in the history of the humanities, the accessible work of art was the great public work, the cathedral or pyramid or temple, perhaps with some works accessible to adherents, who might glimpse the icon or see an image through a screen, or look up to see massive sculptures and paintings. In the pre-Hispanic world, we can imagine the Olmec colossal head or the giant rock outcropping: much of the art there was the performance, in which human protagonists animated vast public spaces. Nevertheless, in much of the world, access was often limited to the private, wealthy viewer,

whether clerical patron or elite collector—and typically available more to men than women, and more available to the well-heeled member of society. Thomas Crow has written compellingly about the response of the mob to the works of the biennial Salon in Paris, starting in 1737; even so, the exceptional quality of this aperture to the public only underscores its rarity.[3]

In the nineteenth century, the study of art in the United States came to life through casts and other replicas, in addition to the formation of museums. The great cast collections offered not only the opportunity to draw and paint and sculpt copies but also to teach art's history, especially when exhibited alongside original works.[4] The first world surveys of art appeared in Prussia during the days of King Frederick IV, where the great royal collections formed the basis of the study of paintings and sculpture by Franz Kugler, who wrote early studies of the world's art and who served at the Prussian court.[5] Translated into English, often with amplifications and excisions, and published on cheap wood-pulp paper, the Kugler corpus created the first synoptic history of art widely distributed around the world. Despite its focus on the Prussian collections, Kugler's compendium nevertheless encompassed, remarkably, the art of the entire known world, including Maya and Aztec works that had been first published by his contemporary and colleague, Alexander von Humboldt, who also held appointment to the Prussian court.[6] The thumbnail sketches in Kugler may give one an idea of different works of art as a historical phenomenon but little sense of their qualities; the uniform draftsmanship of the images makes a late Roman ivory carving look rather like Rembrandt's *Night Watch*! Here we find emergence, but not emergency.

The early history of art history in America has been addressed elsewhere, as told through its protagonists, but not its technology.[7] When Charles Eliot Norton delivered lectures in the "rhapsodic manner of his friend Ruskin," he did so without any pictures whatsoever, the very nadir of technology.[8] Was there a copy of Kugler's illustrations in the room? One tries to imagine what this required: the text about the picture became the text, his words and Ruskin's, perhaps, forming a new literature. Later instruction at Harvard took place in rooms where original prints, drawings, and paintings could be studied directly by students.[9] Reproduction photographs and prints of works of art studded the rooms where some art historians offered instruction; library resources were deployed to their acquisition. But the greatest invention of the era, and the one that allowed art history to flourish across the country by the early twentieth century, was the lantern projector, sometimes known as "magic lantern," and its slides, particularly in its early days.[10]

Professors and public lecturers across the country were drawn to this new technology; following the lead of Heinrich Wöfflin and others in Europe, art historians set up projectors in pairs, to focus on the image in comparison. The quality of the slides sometimes made it possible for works to be seen in exceptional detail, blown up to giant scale, and with brilliant illumination.[11] By 1910, art history had spread across the United States, taught as frequently in institutions without collections as in institutions with them.[12] It is hard to imagine that such dissemination would have taken place without the new technology.

If photography would change everything in the late nineteenth century, cheap photography would transform the study of the history of art even more in the twentieth century, further promoting its study across the United States. The establishment of the University Prints Company underpinned this change. Starting at least by 1907, the first date of a holding in the Yale University Library, "University Prints" folios of five-by-seven-inch pictures were routinely offered in bookstores, and marketed to college students. Sold alongside other required course materials, these were loose-leaf and modestly priced compendia of what were already recognized as important pictures. University Prints provided images to students that they would have had little opportunity to see in any other format, such as the five hundred images of Dutch and Netherlandish paintings, a focus of early collection by European museums and private collections and already addressed by Kugler.[13] Whether monumental or miniature, works were reproduced without attention to scale, and original photography seems to have been commissioned, especially in European museums. These small image folios were selected long before there were textbooks in specific fields, and University Prints allowed the image to stand on its own; when survey studies of regions or time periods were eventually published, in focused subject areas that ranged from Gothic cathedrals to Italian painting or even Pre-Columbian Art, University Prints, in their modest and black-and-white format, offered far more images than any book could. Their very existence may have encouraged instruction in given fields. With their depth of coverage, University Prints pictures were ones that could otherwise be seen by going to libraries, taking over large library tables to pore over one book after another, searching for the rare color image, or the detail from a picture that would take the viewer deeper. University Prints had the great advantage in that most students purchased them, and so had them at home: the pictures could be spread out, arranged like Bingo cards, when major art libraries limited circulation of valuable books laden with plates. Unlike the ordered pictures of Helen Gardner's *Art*

Through the Ages, which first appeared in 1926, the pictures of University Prints invited the student to rearrange them, unburdened by a signature binding, and to create private quizzes of their identifications.[14]

In looking at examples in my own field, I am struck by how much the selections reified a developing canon established first by Pál Kelemen, whose book *Medieval American Art* had made an impact in 1943, and then by George Kubler, in 1962, whose Pelican History of Art put the art of the Ancient Americas—as he first termed it—on an equal footing with the ancient foundations of the Western tradition.[15] William Teel, who with his wife Bertha purchased the University Prints company after World War II, took up the task of writing his own survey, an "Outline of Pre-Columbian Art," to accompany the University Prints of this subject, starting with the selections also included in Kubler and Kelemen; and then, in distinction to all other canon-makers of the period, Teel incorporated Native American art of North America, rarely taught by art historians. Thus, Teel had his own canon-making enterprise, but despite his reliance on Kelemen and Kubler, he did not cite the former, referring mainly to anthropologists, along with George Kubler and possibly Douglas Fraser of Columbia, noted in the volume as F. Douglas (surely a confusion of Frederick Douglas and Douglas Fraser),[16] along with the polymath artist Miguel Covarrubias, who defied disciplinary definition. Through his own observations, Teel intended to amplify the canon, pushing it toward anthropology and archaeology.

But canon-making is only part of the story of University Prints. Most important, University Prints made the art-historical image readily and inexpensively available in the era of the expensive book. Yet the print or photograph of the work of visual art distributed in such packets bore only a pale relationship to the real thing, as did the posted photograph on the wall where students turned for review. Those who had access to museum collections directly recognized just how pale was this relationship.

Starting in the nineteenth century, museums began to grow up on the campuses of colleges and universities in the United States; some courses of instruction depended exclusively on those museum collections. Later, the decision by the Kress Foundation in 1961 to give one dozen works to twenty-four institutions of higher education put powerful, original objects directly in front of students across the nation.[17] The Yale University Art Gallery is an encyclopedic institution, with strong holdings of Old Masters that would have impressed Kugler, from Pollaiuolo to Rubens to Hals, but the rich collection that today encompasses Velázquez,

Magritte, Kiefer, Pollock, and Frankenhthaler, along with a Fante drum and an Aztec calendar stone, makes it possible to teach any period and place in the history of art within its walls. The secondary experience of the book or modern reproduction could be amplified, if not circumvented altogether, by primary experience. Some art historians may still teach the way recalled by early Harvard students of the subject, simply in the collections; new object classrooms have made this possible in many institutions, and especially at Yale.

At the college or university, art historians have constituted a unique set of gatekeepers. For many years, we were the people who had the slides. We were the people who traveled to museums and collections, often to gather images. We were the people who ordered new slides from the freshest publications. We assembled the images that graduate students would deploy in discussion sections. We chose the pictures to post on walls. Some even knew how to fix a temperamental lantern slide projector! We were—or our intellectual parents were—the ones who ordered the University Prints for students to acquire. We wrote the texts that interposed themselves between the object and the observer. We leveraged the knowledge gained in class to explore the work of art in the museum. And the most powerful works provoked their students to beg for something better, or something more. Faculty planned field trips to special exhibitions. Faculty expected growth along all these dimensions: more and better slides, better museum collections, more opportunities to see individual works with students. The economic crisis of 2008 dimmed many of these hopes. For many, the attendant nationwide drift away from the humanities has remained the emergency.

But simultaneously another emergency looms, one that art historians have not universally recognized or figured out how to exploit: the digital age has brought about the emergence, and the attendant emergency, of visual democracy. Just as the printing press and photography and the lantern projector transformed the accessibility of the text or the work of art in the past, this emergency arises from technology. This visual democracy is new: whether one turns to Google images or ArtStor or the seemingly random images of every conceivable work posted by travelers across the planet, or the carefully curated and often high-resolution images of museums, or even Instagram, the image is now king. The constraint of technology that kept the texts of literature, philosophy, and history at the center no longer pertains: it is image that dominates the digital world, the image that does not have to be confined to 140 characters, the image that can now be recognized and identified by various search engines. The text digitized remains the text.

The image digitized brings to life details previously unseen. The image digitized yields tiled comparisons dancing across the screen. The image digitized is often made directly from the original, giving the observer the power to frame or crop a picture anew, offering a fresh view. If we were to remake the humanities and integrate them, to bring the art forms together, why wouldn't we make the work of visual art the centerpiece?

This emergency is an opportunity.

Let me now come back around to the beginning, to the idea that we have an opportunity to claim for art history a more central role, if not *the* central role, in the life of the humanities. Like the text of yesteryear, the visual image is now familiar to students, but it is just that, familiar, known in the abstract, and usually unstudied—and like the University Prints of the twentieth century, known without scale, dimension, and often in its own pale relationship to the original. And like all things disseminated so broadly, generic digital image searches yield a focus on a narrow canon, unmediated by quality or authority of the image. At its best the digital image draws the observer to the museum to see an original, to try to understand what makes Vincent van Gogh's *Starry Night* yield more hits in a Google search than any other work by the painter. And even its worst—a glimpse at that painting, digitally—is an aspect of visual democracy never possible in the past.

There has never been a more important time for art historians to align with and engage with the museum, to see the charismatic power of paint and jade and stone and line and to put students in front of works, both in the moment and by using every technological tool at hand, especially the enlarged detail, the scientific photograph, the chemical analysis that takes the viewer beyond the visible. These new tools move beyond the digital image itself. In this, science is more than a useful tool: science and art inform one another, true partners that engage other disciplines along the way, from history to economics. The technology of the twenty-first century can bring art and science ever closer, changing the center of the humanities.

With the tables turned on the text in the era of the democratization of the image, have art historians changed how they do their work, when they are no longer the first to introduce students to the visual world? Are the two images in comparison—introduced by the lantern projectors of the nineteenth century—a habit or a truly intelligent way to engage with the visual, regardless of the technology? Introductory courses in the history of art have continued to draw substantial

numbers of students at Yale: before his departure from Yale in 2012, Alexander Nemerov filled the Art Gallery Lecture Hall, turning away dozens of students who sought his insights into the visual world, culminating with the rostrum as a site of further performance, in which student improvisational groups staged additional interventions, further enhancing interest. Nemerov even held the title of Vincent Scully Professor. After his departure the numbers of students enrolled in the survey "Art: Michelangelo to the Present" began to climb again in spring 2015, when Tim Barringer took the stage, and in this decade other surveys—of Asian art, of global decorative arts—have grown their audiences. That the last maps humanity's extraordinary three-dimensional works onto strong university museum collections in a form generally unknown in the written survey is part of its appeal. There is a way in which the great art history course may always be the place where the works start to move, and where works come together, as conjured by the compelling narrative, whether the auroch of the cave or the carved bit of wood.

My colleagues and I have not abandoned our aspirations for the powerful, unitary vision of the introductory course, one that can be explored creatively for its ambiguity and one that remains under constant reassessment. Our access not only to the Yale University Art Gallery but also to the Center for British Art, the Beinecke Library, and the Peabody Museum makes it possible for us to interpose nothing more than live mediation between the work and the student. The power of the work in these settings comes from the ways that we engage: dependent on where we stand, where the light falls, how our eyes focus, whether we see colors or lines first, who we are, or what knowledge and experience we bring to the moment of opening our eyes. We bring the works from the museums into the hands-on classrooms; we can assemble in front of paintings without the barrier of glass. When exceptional facture is shaped by insightful vision, and imbued with meaning by the maker, we are in the presence of the most powerful charismatic art form of humanity.

The true emergency in art history will be if we do not respond to the technological challenge that visual democracy poses. The true emergency in art history will come if we do not find more and better ways to put students in front of works in the museum. And if we think it is an emergency now, we can be certain that art history will face yet more of an emergency if we do not seize the opportunity.

1. For a recent debunking of this attribution, see Peter Bahn, "A Lot of Bull? Pablo Picasso and Ice Age Cave Art," http://www.aranzadi-zientziak.org/fileadmin/docs/Munibe/200503217223AA.pdf (accessed July 7, 2015).

2. Robert S. Nelson has addressed the impact of the projected slides and the persuasive lecture, from Heinrich Wölfflin to the portrayal of art-historical instruction in Wendy Wasserstein's *The Heidi Chronicles*: "The Slide Lecture, or the Work of Art 'History' in the Age of Mechanical Reproduction," *Critical Inquiry* 26, no. 3 (2000): 414–34.

3. See Thomas Crow, *Painters and Public Life in Eighteenth-century Paris* (New Haven: Yale University Press, 1986).

4. See Craig Hugh Smyth and Peter M. Lukehart, eds., *The Early Years of Art History in the United States* (Princeton: Princeton University, Department of Art and Archaeology, 1993), particularly the essay by Phyllis Williams Lehman, "The Study of Art at Smith College," 65–68; see figs. 51, 53, 54, 55, 58, 59, 68, 69, 112.

5. Franz Kugler served both Frederick III and Frederick IV. His first foray into the study of art began with a guide to the pictures in the Prussian galleries open to the public: *Beschreibung der Gemälde-Gallerie des Königl. Museums* (Berlin: Carl Heymanns Verlag, 1838); followed by true world surveys that included Asian, African, and Pre-Columbian art, beginning with the *Handbuch der Kunstgeschichte* (Stuttgart: Ebner & Seubert, 1842). His relationship to the king is underscored by a three-page dedication to his patron, extolling the monarch's virtues. For an early translation, see *A Hand-book of the History of Painting*, translated from the German by a lady, ed. C. L. Eastlake (London: John Murray, 1842). The "lady" in question here was Elizabeth Rigby, Lady Eastlake. The second edition of Kugler (Stuttgart: Ebner and Seubert, 1848) appeared in a single volume of text with lavish illustrations bound as a separate "atlas": every illustration has been drawn by the same hand, yielding a sort of sameness to all illustrations, all line drawings; the sole hand-colored squib in the Yale copy is of the Codex Nuttall.

6. Alexander von Humboldt, *Vues des Cordillères, et monumens des peuples indigènes de l'Amérique* (Paris: Librairie grecque-latine-allemande, 1816); available online https://archive.org/details/vuesdescordillo1humb (accessed July 7, 2015); most of Kugler's Maya examples came from John Lloyd Stephens, *Incidents of Travel in Central America, Chiapas, and Yucatan* (New York: Harper & Brothers, 1841).

7. See note 4 above.

8. Sybil Gordon Kantor, "The Beginnings of Art History at Harvard and the 'Fogg Method,'" in *The Early Years of Art History*, ed. Smyth and Lukehart, 163–64.

9. *The Early Years of Art History*, ed. Smyth and Lukehart, figs. 115, 116, and 122.

10. H. B. Leighton, "The Lantern Slide and Art History," *History of Photography* 8, no. 2 (1984): 107–18.

11. Leighton, "The Lantern Slide"; Nelson, "The Slide Lecture."

12. E. Baldwin Smith, "Appendix II: The Study of the History of Art in the Colleges and Universities of the United States," in *The Early Years of Art History*, ed. Smyth and Lukehart, 12–36.

13. H. H. Powers and Mary Montague Powers, eds., *The University Prints, Student Series D, Art of the Netherlands and Germany: Five Hundred Reproductions Illustrating the Flemish, Dutch, and German Schools of Painting, from the Early Fifteenth to the Eighteenth Century; German Sculpture from the Eleventh to the Seventeenth Century* (Boston: Bureau of University Travel, 1907).

14. Helen Gardner, *Art Through the Ages: An Introduction to Its History and Significance* (New York: Harcourt Brace & Company, 1926). For the second edition in 1936, pictures appeared on the page, with the text, and their number greatly expanded, facilitating visual study.

15. Pál Kelemen, *Medieval American Art*, 2 vols. (New York: MacMillan, 1943); George Kubler, *Art and Architecture of Ancient America: The Mexican, Maya, and Andean Peoples* (London: Pelican, 1962).

16. William Teel, *An Outline of Pre-Columbian and American Indian Art* (a supplement to University Prints Series N, Section III; Winchester, MA: University Prints, 1976). Teel limited his interventions to traditions outside the Western tradition.

17. http://www.kressfoundation.org/research/campus_art_museum (accessed July 7, 2015): Corrinne Glesne, *The Campus Art Museum: A Qualitative Study*, part 1, "The Great Kress 'Giveaway'" (2012).

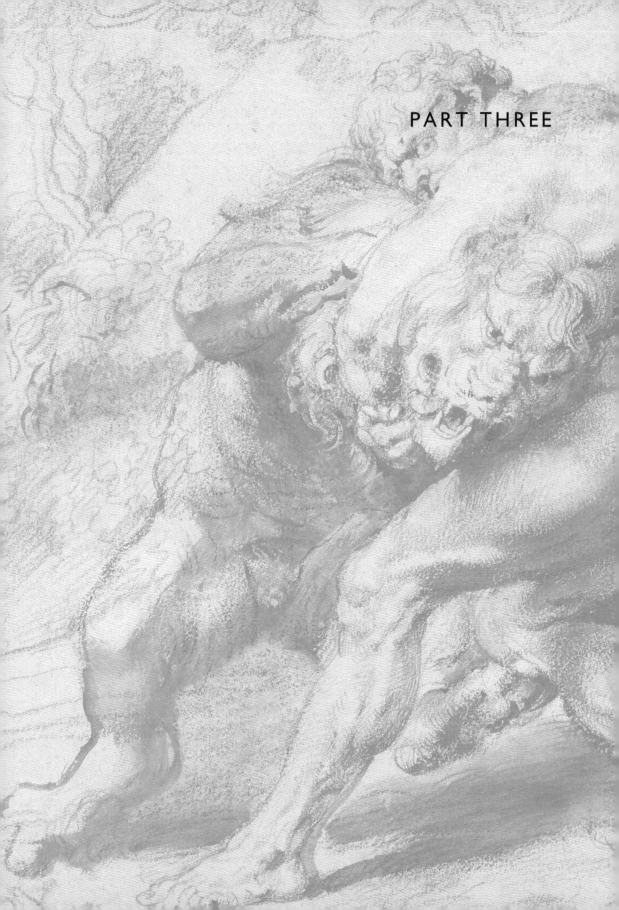

PART THREE

Old Divisions and the New Art History

Howard Singerman

In 1982, the College Art Association's *Art Journal* published a special issue, edited by Henri Zerner, entitled "The Crisis in the Discipline," featuring articles about art history's past and present by Joan Hart, David Summers, O. K. Werckmeister, Rosalind Krauss, and Donald Preziosi. In his introduction, Zerner laid out his bill of particulars, the crisis posed by a younger generation of art historians to the discipline's purview, its practices, and its underlying assumptions:

> A growing minority of art historians, especially those of the younger generation, are convinced that art history, which at the turn of the century seemed to be at the forefront of intellectual life, has fallen behind; that far from progressing it has deteriorated and reduced the thought of its founders, Morelli, Riegl, Wölfflin, and others, to an uninspired professional routine feeding a busy academic machine. It has also been pointed out only too often that this established art history with its stylistic analysis, iconographic readings, monographs, and catalogues is by no means the neutral, objective activity that it claims to be and that it is, instead, in the service of the dominant ideology; it is deeply involved with the market, which determines the object of studies to a considerable extent.[1]

It may be that these issues remain on the table even now some thirty years later, certainly the last one: the involvement of the market and its role in determining art history's object of study. Indeed, when Patricia Mainardi revisited Zerner's special issue on its twenty-ninth anniversary, at the annual conference of the College Art Association (CAA) in 2011, with the title "The Crisis in Art History," every member of her panel took up the issue of the market—albeit under a different name: the rise and seemingly absolute victory of contemporary art history. Courses in contemporary art were overflowing, courses in the Renaissance or non-Western fields went begging, research and language skills were suffering. Pepe Karmel, one of Mainardi's panelists, addressed the force this way: "If we do not [teach it], another department will: Studio Art or Visual Culture or Curato-

rial Studies. If we do not embrace contemporary, the money and the students will drain out of art history."[2] It is the "coming true," so to speak, of the agency of the market in art-historical practice.

In 1982, when Zerner wrote his introduction to the crisis, there were very few historians of contemporary art—according to the CAA's annual guide to doctoral programs in art history in 1984, out of all the faculty members listed at forty-seven PhD programs, there were a total of three individuals who listed contemporary art among their specialties, and only one, Ann Gibson at Yale, listed art since 1945 as a sole area of expertise. Ads for modernists with an interest in contemporary art had begun to appear by the handful in the late 1980s, and 1994 might mark a watershed, with University of California–Los Angeles's search for a "specialist in contemporary art, criticism, and theory with interest in European Modernism." By 1999, twenty tenured or tenure-track faculty in the CAA's annual guide listed themselves as contemporary art historians or had a primary research interest in contemporary art. There were by then fifty-five doctoral programs in art history. There are now fifty-nine and another handful in related fields, decorative arts or design history, and, as Karmel suggests, in visual and cultural studies.

I have slipped here, in my citations of CAA listings and directories from the *discipline* of art history, with its broadly shared discursive practices, its relatively agreed-upon canon, its understood divisions, and its standards and protocols of proof and evidence—those things that were threatened in Zerner's crisis—to the art history *department*, the earthly, pragmatic, institutionally situated, and only ever partial and approximate mirror of the discipline. It is there, in departments rather than disciplines, that this paper dwells—turning Hegel on his head perhaps. It may be only accidental, far from dispositive, but one might read the difference in the concerns of Zerner's "Crisis in the Discipline" and Mainardi's "The Crisis in Art History"—whose papers dealt with declining enrollments and declining budgets, as well as the misshaping influence of contemporary art history—as the triumph of the department over the discipline. But triumph would not be quite the right word, given that departments of art history are themselves being hollowed out in many institutions. Rather, what seems to have taken place in the years between 1982 and 2011 is the full emergence of what Bill Readings termed in 1996 "the posthistorical university," a university that "no longer participates in the historical project for humanity that was the legacy of the Enlightenment: the historical project of culture."[3] Readings names this new and insistently presentist university—a university characterized by the bureaucratic and content-free

language of rubrics, assessments, and outcomes—the University of Excellence. (As I first typed this sentence some months ago, the following e-mail arrived: "If your department has a rubric for teaching evaluations, could you bring it to the meeting today or email it to me. My department, POLSC, is thinking of moving from narrative to rubric-type teaching evaluations.") Readings draws the term "Excellence" from the new university's discourse, a watchword and a particular tic of bureaucratic language that can be applied university-wide. My former university, the University of Virginia, has a Center for Undergraduate Excellence; it hosts a Center for Nonprofit Excellence and has had its "telehealth" center named Cisco Healthcare Center of Excellence. Nearby there is Virginia Commonwealth University's Division for Inclusive Excellence—its office for diversity—and the Autism Center for Excellence. "The appeal to excellence," Readings writes, "marks the fact that there is no longer any idea of the University, or rather that the idea has now lost all content. [It is] a non-referential unit of value entirely internal to the system. . . . All the system requires is for activity to take place, and the empty notion of excellence refers to nothing other than the optimal input/output ratio in matters of information."[4]

These general complaints and Readings's particular interpretation are now two decades old, but they are, I would argue, still pertinent, as more and more campuses have caught up with his description. The goals of the new university are determined not by the demands of history or of a shared past, a broad definition of culture or nation or citizen. Rather, they are determined by the satisfactions of individual arenas of consumers and constituents, as determined by polls and surveys and rankings, to which we are held accountable in the name of accountability. "Excellence," Readings writes, "is the common currency of ranking."[5] I am happy to say that the MFA program in studio art at Hunter College where I now teach ranks thirteenth in the nation among Graduate Schools of Fine Arts in the most recent *U.S. News & World Report* survey (2012)[6] and that my former employer, the University of Virginia, ranks second among public colleges and universities with a national profile—some years it ranks first. But rankings and rubrics of the University of Excellence impact some schools differently than others, and categorically. While UVA is second among public national universities, tied with UCLA, it ranks twenty-third overall. The first public school on the list, University of California–Berkeley, comes in at number twenty.[7] Berkeley ranks near the top of the fifty-eight programs included in the most recent National Research Council (NRC) assessment of doctoral programs in the History of Art,

Architecture, and Archaeology, first released in September 2010 and revised in April 2011; Virginia comes in near the bottom, whether measured by the "criteria that scholars say are most important" (what the NRC termed its S- or Survey Rankings) or by its similarity "to programs viewed by faculty as top-notch" (the NRC's R-rankings).[8] (The R stands variously for both "regression-based" and "reputation," an exceptionally important criterion for the 1995 NRC assessment and one that the 2010–11 survey treats quite carefully, "asking faculty raters to provide reputational program ratings [R] for a sample of programs in a field and then relating these ratings, through a regression model that corrected for correlation among the characteristics, to data on the program characteristics."[9]) Seven of the top ten schools in the initial 2010 Survey Rankings are private, as are eight of the top ten on the R-rankings. Nine of the bottom ten are public, on both scales.[10]

Whether weak or strong, departments are always only partial; there are unfilled lines and unproductive scholars, and a great deal that is not measured by NRC rankings: first and foremost, the time and energy invested in teaching. Long ago, Erwin Panofsky lamented, and perhaps lampooned, the American university's focus on teaching; where the European university "is a body of scholars, each surrounded by a cluster of *famuli*, . . . [t]he American college is a body of students entrusted to a teaching staff . . . [t]oo often burdened with an excessive 'teaching load.'" It is, he writes, "a disgusting expression which is in itself a telling symptom of the malady I am trying describe," and one we have long since learned to take for granted.[11] Art history in the United States does have institutions that look far more like Panofsky's "humanistic discipline" than they do like departments, research institutes like the Clark or the Center for Advanced Study in the Visual Arts (CASVA) at the National Gallery that engage fully in—and indeed stand for—the discipline's history, its debates, and its aspirations. Of the eighteen predoctoral dissertation fellowships awarded by CASVA for the academic year 2014–15, two went to doctoral students at public universities. For the record, thirty-four of the fifty-eight doctoral programs in art history surveyed by the NRC—just under 60 percent—are in public universities. My bean-counting here, and in the talk I delivered at the Clark, is spurred in part by my position as the only representative of a US public college invited to speak of Emergency.

The reasons for the absence of public universities in the NRC rankings or in the halls of the National Gallery are twofold, at least. And here I will speak much more parochially than Readings. That is, I won't go right to the decline of the nation-state and its foundational narratives, though I will speak of state

legislatures. Patricia Mainardi recalls an e-mail asking for nominations of "15 impressive PhD students" who would go to Albany, New York, to meet with state legislators and participate in an event called "Research that Matters: An Exposition of Graduate Research in SUNY and CUNY." Among the bullet points defining the criteria for choosing these students were that their work "should be relevant to state jobs and job creation, as well as the state economy in general—it should be research that 'matters.'"[12] The first reason is that the terms of the rankings for research departments in the humanities are in many ways out of reach for public institutions: the "economization of knowledge" that Darby English cited in the Clark's invitation to this conference hits public institutions differently than it does private ones. The NRC economizes, too, or one could think of its criteria as economic in the last instance as well: scholarship and fellowship support is a crucial determinant, as are travel funding and support for faculty research and publication. The time required to earn a degree and graduate placement matter to them (as they do to state legislatures—though maybe for different reasons), and then there is that crucial, and crucially tautological determinant, reputation. Excellence, reputation, and rankings do a number of things locally, in any given institution, and one of the things they do is to nationalize them.

The initial release of the NRC rankings at my institution was met with shock and dismay, and by often defensive faculty meetings across the humanities and social sciences attended by representatives of the dean's office; anecdotally, I know we were not alone. The most concrete response to the rankings, and to the NRC's criteria, was an assessment of the size of departments and, overall, a marked reduction of the number of students admitted to many of our graduate programs. A conscious shrinkage of graduate enrollments, particularly in the humanities, had begun nationwide by 2009, in the first year of the recession, "with some institutions talking about short-term budget adjustments while others see broader shifts ahead."[13] The NRC report provided a road map for the broader shifts, and guidelines for "right-sizing" programs—guidelines that didn't need to seem merely short-term or budgetary. The goal, as our dean said, was to become less like the University of Michigan and more like Stanford. And in case we didn't understand the code, it was spelled out for us: we should think of ourselves less as a service university and more as an elite one—less public, more private. In the graduate program in Art and Architectural History, enrollment went from an average of ten to twelve a year, some with funding, full or partial, most without, to an upper limit of five students, fully funded for five years. We were urged to end

the practice of admitting students seeking the master's degree—or students whom we thought capable of only an MA—in part because the NRC could only count students who left after the MA as students who had failed to complete the PhD. The following year we were encouraged to offer proposals for a new free-standing, tuition-bearing MA program, siloed off from the PhD, tailored to specific employment outcomes: curatorial or museum studies, image collection, and archiving. For students still on the books of the PhD programs in the Graduate School of Arts and Sciences, the charge for maintaining enrollment—for writing a dissertation—went up both precipitously and significantly. The purpose may well have been to accurately reflect costs or, simply, to generate revenue, but it also works to drive up completion rates or, failing that, to drive out of the system those who threatened not to complete—and, in the long run, to drive rankings.

These are rational moves, taken by both public universities and private ones. And they are, so to speak, disciplinary—where discipline means both the form of professional discourse and the shaping and forming of its participants, and punishment. The trend toward shrinking graduate programs in the humanities in particular is national, and among universities with national aspirations, the purpose is not merely cost-cutting; the same money, maybe even a bit more, is redistributed among winning and losing departments. It turns out that a flagship state institution or a nationally ranked private university, whatever its mission, may not need a PhD in German or Slavic Languages—or can get by with one that admits one or two students a year—the deck chairs are rearranged, based on outcomes, on current rankings and assessments, and, perhaps, on job prospects and placements within the academy. But none of these are assessments of the contents or coherence of a program—its disciplinarity—or of the strength or commitment of its teachers. These are specifically external comparisons in a nationalized market, and something that can be shown to donors, foundations, and potential graduate students, precisely as they choose to give to or go to one institution rather than another. They are shown to state legislators, as well, and to the state officers and commission members who approve programs and close them, and allot the number of teaching assistantships and tuition waivers state schools receive. It is worth noting here that overall state support for higher education has dropped significantly since the recession, and indeed over the past decade. In Virginia, educational appropriation per student (FTE) declined 26 percent between 2008 and 2014. Over that same period, revenue from tuition increased nearly 25 percent.[14]

However rational the choice to shrink students and programs, these cuts work against the mission of public universities. There was genuine anguish on the part of my colleagues, many of whom told stories of individual students who had come, mostly self-financed, from out of the blue and who completed viable dissertations. Or at least dissertations that fulfilled them—high school Latin teachers or former army officers or lapsed lawyers, students we could never accept now, who present too great a risk. Students who were local, for whom we were the local school. At Hunter College, we do not have the PhD; we have some one hundred MA students, many of whom are already at work in the art industry in New York when they come to us—as curators and researchers, or in related museum and gallery positions. Most of our MA classes meet in the late afternoons and evenings, precisely to accommodate that student body; it is, in this sense and others, old-school public education, and, in its way a service to the city and the state. The City University of New York's PhD in art history is offered by the CUNY Graduate Center, and there, too, PhD enrollments have been significantly slashed in the past three years in order to give greater financial support to fewer students. The Graduate Center was ranked relatively high in the NRC's 2011 R-rankings, but significantly lower in the S-rankings, and toward the bottom in Student Support and Outcomes, with very few students receiving financial support in the first year, and very few completing the PhD in eight years or less. It was, before 2013, among the largest PhD programs in the country, and many of the students it attracted were, like the students we currently have in the MA program at Hunter, working, and often full time. Founded in 1971, the art history program at the Graduate Center was a local endeavor—a New York school devoted specifically to American art and modern art and criticism, fields (its founders argued in Albany) that were underserved at Columbia and NYU—responsive to and situated within a strong local dialogue, with students already engaged in that conversation and in the art world. There is a real tension, and maybe not a resolvable one, between the public mission of expanding educational opportunity—of accepting part-time students and acknowledging that many students may not complete the PhD, precisely as their interests and lives take them elsewhere—and the disciplinary and university mission of excellence.

I want to return briefly to 1982 and to Henri Zerner's "Crisis in the Discipline." The discipline was changing in a variety of ways in that moment; this is the renaissance that Thomas Crow referred to in his essay "The Perpetual State of Emergency: Who Benefits?" (in this volume). The "new art history" was both

announced and interrogated that same year at a conference at Middlesex Polytechnic entitled "The New Art History?"—with a question mark. The Rees and Borzello anthology *The New Art History* came out in 1986, without the question mark.[15] While the upheavals named by the phrase "the new art history" clearly led to remarkable scholarship and an expansion of voices and of purview in the discipline—and at moments, to a more engaged art history—it has in its consequences also been handy to administrations. The expansion of art history's scope to include the objects and practices of everyday life—visual culture and material culture— and of its theoretical and methodological concerns to engage more broadly across the humanities and social sciences has been more than laudable, nearly essential. And it has led to the expansions of programs that bear those names—material culture, visual culture, critical studies, art and theory. I am the product of one such program, perhaps the first: the University of Rochester's program in visual and cultural studies, a doctoral program driven by the commitment and interests of individual faculty in art history, comparative literature, film studies, women's studies, French, and English. Such programs are valuable—certainly the program at Rochester was crucial for me—but perhaps they do lead to a certain kind of disciplinary deskilling, as Crow once charged (indeed, as an entire issue of *October* once charged).[16] Certainly they have been used to cover over or to bridge the inadequacies of the traditional departments out of which they have been formed, hollowing out the departments or collapsing them into one another for greater cost savings. Comparative Literature has been closed at Rochester and French has been folded into the Department of Modern Languages and Cultures, a department whose mission is, to quote its website, to "support interdepartmental links" with a wide variety of programs that are literally linked through its website—African and African-American Studies, Film and Media Studies, Gender and Women's Studies, History, Polish and Central European Studies, and Visual and Cultural Studies—only one of which, History, is a department; each of the others is in one way or another carved out of or aggregated from departments.[17]

Interdisciplinarity is certainly a good idea; and I was interested in Mary Miller's description of "Thinking the Humanities in the 21st Century," a Mellon-funded initiative at Yale designed to allow faculty to imagine what knowledge would look like if there were no departmental divisions. This has benefits not only for faculty and students, but also for administrators. As an associate dean remarked to the *Yale Daily*, "Universities think of knowledge as a long-term prospect, so we have departments in subjects that have been around for a long time and we think

will be around for a long time. . . . [T]his is a way of being flexible and supporting creation of new knowledge without creating structure you can't get rid of."[18] In some places this flexibility is administratively and economically enforced. Deans and foundations demand it. Since the onset of the recession, a significant number of the new lines universities have been able to advertise in the humanities and social sciences have been directly funded by national philanthropic foundations, almost always explicitly crafted to promote interdisciplinarity. Administrators, in their turn, take the charge for interdisciplinarity to heart, in ways that impinge directly on the pragmatics of departments. At Virginia the year I left, it became the policy of the College of Arts and Sciences that all search committees for any senior faculty position must include a representative from another department or program; for junior positions, partners are recommended rather than required. The policy may respond to goals that are in many ways laudable, but it does suggest an image of any new faculty member as a free radical, not in the 1960s sense but in the chemical one—always ready to bond with another department, another program. Tenure committees, too, must include a representative of a neighboring department. Perhaps this is simple mistrust—the deans do not trust their departments to conduct their business appropriately—but that has real curricular, programmatic, and disciplinary effects.

The new possibilities for art history and for those programs that stand adjacent to it or in its place that emerged in the 1980s and 1990s are truly valuable. Certainly the expansion of non-Western fields, and of underrepresented histories both within and outside the West have been particularly important, even transformative. But it is part of the cynicism of the contemporary university that these new fields are opening precisely as languages are being cut, and, even worse, student time is being cut—the time to earn a degree is a crucial metric after all, and it often cannot absorb the learning of a third or fourth language, of Hindi or Sanskrit. And the cost of student time is skyrocketing.

It may be that the most elite and elitist forms of art history training, the sort Panofsky described (when he was already decrying American art history teaching in the 1950s), with its deep archival research and its broad linguistic and scholarly reach, might be in the final analysis too expensive for state schools, too expensive for more than a very few schools. But it may be what we should stand for now. In a brief conversation with Darby English at the start of the conference, he suggested that it might be more interesting if we didn't have answers. So I won't have one here. But I do find that what I have come round to in the end is a

defense of departments, of those same policed boundaries that Thomas Crow and Mary Miller disparaged in their papers—and maybe a defense of old-style *Kunstgeschichte*. I think I would at least defend the long-term, serious research project, and the long time it takes to complete it: the dissertation completed over many years, or not completed at all, but which has formed or transformed its author intellectually; the time of the student rather than, to quote the Situationists on "The Poverty of Student Life," "the straitjacketed daily space-time organized for his benefit by the guardians of the system."[19] Crisis, as Kajri Jain argues in this volume, is to time what spectacle is to space—and maybe the continual crisis that "Art History and Emergency" was intended to address is a way of continually speeding up the university, of ensuring outcomes. I would stand with Molly Nesbit and her call for slow learning, and her demonstration of a local art history—or at least a questioning of how it has become nationalized at the cost of both departmental governance and broad educational access. And then there is the political: The value of individual departments is that they are still, at least for the time being, where collective power lies for faculty within the university to determine the shape of a discipline, and reciprocally to allow the discipline to determine the shape of departments, to continue to imagine any discipline at all in the historical sense. Weirdly, departments may have come around politically as a sort of Luddite, rear-guard friction against the smooth running of the University of Excellence.

1. Henri Zerner, "Editor's Statement: The Crisis in the Discipline," *Art Journal* 42, no. 4 (Winter 1982): 279.

2. Pepe Karmel, "Just What Is It That Makes Contemporary Art So Different, So Appealing," *Visual Resources: An International Journal of Documentation* 27, no. 4 (2011): 323.

3. Bill Readings, *The University in Ruins* (Cambridge: Harvard University Press, 1996), 5.

4. Readings, *University in Ruins*, 24.

5. Readings, *University in Ruins*, 24.

6. http://grad-schools.usnews.rankingsandreviews.com/best-graduate-schools/top-fine-arts-schools/fine-arts-rankings?int=aa0a09 (accessed July 8, 2015).

7. http://colleges.usnews.rankingsandreviews.com/best-colleges/rankings/national-universities/data (accessed July 8, 2015).

8. The descriptions of the National Research Council's S- and R-ratings are from the *Chronicle of*

Higher Education, http://chronicle.com/article/NRC-Rankings-Overview-History/124737 (accessed July 8, 2015).

9. Committee on an Assessment of Research Doctorate Programs, Jeremiah P. Ostriker, Charlotte V. Kuh, and James A. Voytuk, eds., *A Data-Based Assessment of Research-Doctorate Programs in the United States* (Washington, DC, 2011), 73.

In the NRC's own text, which is quite ambivalent about the term "Reputation" and its effectiveness as a measure, the R stands variously for "Reputation" and "Regression". In the quoted passage, the R designates "reputational program ratings (R)," but elsewhere the editors offer Regression; see, for example, p. 21: "The results of the regression of these ratings on the measures of program characteristics are used to develop another range of illustrative rankings, the R-rankings (for regression based)."

10. In 2007, before the release of the NRC assessment, a private firm called Academic Analytics measured faculty research productivity among the nation's top research universities. Among their findings were that "average rankings of departmental programs . . . based on the company's "Faculty Scholarly Productivity Index," which takes into account grants received, awards bestowed, and books and journal articles published, show that programs at private institutions are consistently ranked higher than corresponding programs at public universities." "The elite publics—among them the University of California at Berkeley and the flagships in Wisconsin, Washington, Virginia, North Carolina, and Michigan—are ranked 13, 14, 17, 18, 25 and 27." Elizabeth Redden, "Are Public Universities Losing Ground?" *Inside Higher Ed*, posted March 14, 2007, https://www.insidehighered.com/news/2007/03/14/analytics (accessed July 8, 2015).

11. Erwin Panofsky, "Three Decades of Art History in the United States: Impressions of a Transplanted European," in *Meaning in the Visual Arts* (Chicago: University of Chicago Press, 1982), 338, 341.

12. Patricia Mainardi, "Art History: 'Research that "matters"'?" *Visual Resources: An International Journal of Documentation* 27, no. 4 (2011): 305.

13. Scott Jaschik, "Top Ph.D. Programs, Shrinking," *Inside Higher Ed*, posted May 13, 2009, https://www.insidehighered.com/news/2009/05/13/doctoral (accessed July 8, 2015).

14. State Higher Education Executive Officers Association, *SHEF: FY 2014: State Higher Education Finance*, tables 5 and 6.

15. A. L. Rees and Frances Borzello, *The New Art History* (London: Camden Press, 1986).

16. See "Questionnaire on Visual Culture," *October* 77 (Summer 1986): 24–70, and Rosalind Krauss's "Welcome to the Cultural Revolution," in the same issue, 83–96.

17. See http://www.rochester.edu/College/MLC (accessed July 8, 2015).

18. Jane Darby Menton, "Faculty to Attend Mellon Workshops," *Yale Daily News*, April 19, 2013,

http://yaledailynews.com/blog/2013/04/19/faculty-to-attend-mellon-workshops/ (accessed August 28, 2015).

19. U.N.E.F. Strasbourg, *On the Poverty of Student Life: considered in its economic, political, psychological, sexual, and particularly intellectual aspects, and a modest proposal for its remedy*, http://theanarchistlibrary.org/library/u-n-e-f-strasbourg-on-the-poverty-of-student-life (accessed July 8, 2015).

Art-Historical Alterity in the Post-Colony

Patrick D. Flores

A potent way perhaps to evoke the notion of crisis or emergency is to remember a moment in history in which a certain resource is threatened to the point of near exhaustion. An instance would be the "oil crisis" pervading the air in the Philippines in the 1970s. Resonating for years were the various turns of this phrase in the time of Ferdinand Marcos, who significantly invested in a certain Third World globality partly as a fallout of the oil crisis in 1973. According to Marcos's energy minister, "When the Arab exporting countries decided to turn off their oil valves in 1973 as a result of the Yom Kippur War, the action had a seismic effect on the world economy."[1] The dependence of the country on imported crude was "nearly total" and with a threefold increase of the price of the barrel, the prospects could only be grim. The recourse of the government—and this is instructive in the explication of a crisis—was to turn to nature and the national: to exploit "indigenous energy resources like oil, coal, geothermal steam, uranium and even energy crops"; and to set up a national oil company to operate a national oil industry and compete with the foreign oil cartel.[2] How the world economy, the wealth of the earth, and the artifact of nation are constellated in this precarious scene is telling.

Marcos hosted the ministerial meeting of the Group of 77 three years later in Manila. The coalition, founded in 1964 within the United Nations for developing nation-states, carved into sharp relief the North–South dichotomy to challenge the postwar liberal international economic regime.[3] In his remarks to the ministers titled "Manila and the Global New Society," Marcos invoked meetings and declarations such as the Bandung Conference (1955), the Algiers Charter (1967), and the Lima Declarations (1972 and 1975) as the context within which to propose the transformation of the Group of 77 into a Third World economic system. According to the Philippine president, who in 1972 declared martial law to supposedly save the republic from both communism and the oligarchy and to inevitably discipline as well as prime the body politic for development, it was imperative for the "poor to provoke a crisis of conscience" amid the "irreversible descent into the bottomless pit of deprivation and want by 70 percent of the world's population."[4] The conference shared Marcos's sentiment, even as his government was quickly turning into a military autocracy, and reaffirmed that a "new

international economic order is essential for the promotion of justice[,] . . . peace and international co-existence, owing to the ever-increasing interdependence of nations and peoples."[5]

Ferdinand's wife, the First Lady Imelda, for her part, ostentatiously choreographed the spectacle of this new international economic order that morphed through the edifices of culture; she reclaimed in 1969 a large part of the fabled Manila Bay for a cultural center she called the Philippine Parthenon. In a speech before the delegates of a meeting of the World Bank and the International Monetary Fund in Manila, she depicted the stark contrasts in the city as a montage that juxtaposed, as she said, "shrine and shanty . . . the shining future against our impoverished past." Imelda portrayed this time as awkward because it was transitional, and she elaborated on the alternation of contending visions from the "beginning of time" to "remote sensing." In her words:

> Further, we have freed ourselves from the excesses of transplanted cultures. We have gone to our past and our roots, a rich indigenous culture that continues to flourish among our more than 85 national cultural tribes. Fortunately, a few years ago, we discovered the Tasadays—a tribe of Stone Age Filipinos hidden for centuries in the rain forests of Mindanao. In them we see our origins: the purity, the gentleness and the beauty of our land and people at the beginning of time.
>
> Last month, we assembled in Manila, an international conference of scientists to discuss how science and technology should be harnessed to cope with the problems of human survival. With the Philippine experiences as a frame of reference, no aspect of modern life escaped its scrutiny. From human habitat to sea-farming; from the population explosion to solar energy; from storm control to oceanography; from telemedicine to remote sensing.[6]

Scarcity

Crisis is replayed here in this rather shrill register partly because it references a trope of scarcity and perhaps a kind of superadequation[7] of a Third World modernity to be contemporaneous with a global order and to acquire a level of value in a putatively expanding formation or collective, whether it be a canon of art or a community of nations. A crisis in art history is like a crisis in a depleted and developing country that is compelled to re-articulate itself across a different axis

of forces as both actually existing labor and possible consciousness. This history of world making in the seventies in light of the exceptional 1973 oil crisis that ramified across the United States, West Asia, and Latin America is this paper's trajectory into a crisis of the history of art and the discipline of art history within the extensive frame of the humanities, which is yet another contentious rubric of knowledge making.

This crisis and its concomitant emergency may be cast as a kind of scarcity. There is practically no art-historical discipline in Southeast Asia in the present, if we are to strictly enforce the requirements of the discipline as practiced in Western Europe and North America. How a history of art is cobbled together even in the absence of a discourse that underwrites it may be unraveled by way of cases in the Malay archipelago, specifically in Singapore and in the Philippines. T. K. Sabapathy begins his history of the history of art in Singapore in the year 1967 when two books on Southeast Asia came out: *The Art of Southeast Asia* by Philip Rawson and *Art in Indonesia: Continuities and Change* by Claire Holt (fig. 1).[8] The former proceeded from the history of art; the latter from the polemics on culture, but both nevertheless distended the term "art" into a transcultural and transhistorical category with only a shift in orientation, one of possession (of Southeast Asia), the other of location (in Indonesia). This device of the polemic, which in the seventies would refigure as a manifesto, is of interest because it introduces a particular diction and tenor of the crisis in art history by converging with "aspirations towards the formation of new nations or states and at other times revolv(ing) around heightened claims of individuality and the self."[9] In this schema, Holt, born in Latvia, was an exemplary personage because of her wide sympathies: dance maker and ethnographer, choreologist, critic, journalist,

Fig. 1. Cover of *Art in Indonesia: Continuities and Change* by Claire Holt, Cornell University Press, 1967

scholar, and colleague of Margaret Mead and Gregory Bateson. Her project of imagining Indonesia aesthetically generated dance, ethnography, and art history that mingled orientalism and colonial modernity.[10]

In the Philippines, the history of art was imagined as part of the humanities and liberal education. In the University of the Philippines, which was established by the American colonial administration in 1908, liberal education was at the heart of the pedagogy, prompting an attentive observer to ask: "How was this concept, traditionally seen as the education of a free man, yet carrying its own contradictions as having been developed by the Greeks in a slave-owning society, translated in terms of a university for Filipinos, run under the supervision of a colonial master?"[11] In many ways, this notion of art was the point of crisis in the making of history. The story of the humanities and art history in the University of the Philippines may partly touch on the process of nation-building in the fifties after the Pacific War and the search for national identity; the Cold War and American foreign policy that integrated the arts within the discourses of development and democracy; and the turbulent years of the seventies that saw the rise of an authoritarian government in Manila and the intense struggles against it.

The course Humanities I, titled Introduction to the Arts, was instituted in the university in the academic year 1955–56. The pioneer professor Josefa Lava recounts that in the same year, Albert M. Hayes, professor of English at the University of Chicago, taught in Manila under the auspices of a Fulbright grant. He was tasked to initiate the course, together with colleagues from the English Department. According to Lava, Hayes brought with him slides and tapes of music, and later, sets of the Chicago manuals *Learning to Look* by Joshua Taylor and *Learning to Listen* by Grosvenor Cooper as textbooks (figs. 2 and 3).[12] Lava describes the pedagogical orientation to be shaped by the University of Chicago and Professor Hayes thus:

> [The] Humanities . . . hewed very close to the content of the manuals or what must have been the University of Chicago approach. The course was primarily designed to make the students consciously aware of what constituted a work of art and why it affected them the way it did, as far as it was possible (without the necessity of lecturing on art movements and historical styles) to draw the values and meanings from each particular work discussed in class. The students were made to grapple with the expressive elements, first in isolation, to enable

Fig. 2. Cover of *Learning to Look* by Joshua Taylor, University of Chicago Press, reprint 1981 [1957]

Fig. 3. Cover of *Learning to Listen* by Grosvenor Cooper, University of Chicago Press, 1957

them to see as clearly as possible the distinctive behavior of each expressive element, later in their interrelationships, and still further, the distinguishing characteristics of the major types of the visual arts, music, and literature. In other words, the main thrust of the course was to make the students understand and appreciate the primary function of art which is to objectify feeling or the inner life, something impossible to achieve through the use of discursive thought.[13]

Across these registers, the "human" was seen as being refused and being redeemed in culture and its aestheticization in art. It may seem then that the recovery of the humanities as a trajectory of teaching art or art history allows for a critique of idealism, of either art or history, as well as reclaiming some kind of postcolonial entitlement to the modernities of both art and history so that stories and their ecologies could finally be told. Within a broad humanities framework, the autonomy of art and the specialization of its study were likewise construed as

complicit in the fragmentation of the human and therefore a supplement of the colonial.

In this light, the art that the humanities was trying to articulate within its history and the history of Philippine culture aspired to a wholeness amid perceived colonial alienation. The study of art was a study of the processes of Westernization and modernization, on the one hand, and of dehumanization and decolonization, on the other. These processes played out in what the course emphasized as a "critical appreciation of the arts" without foreclosing the possibilities of what is made to appear as the unmediated sublime. According to Lava: "I can never forget the momentary hush that always sweeps a classroom of forty or so students . . . when I flash a slide of Michelangelo's *Moses* or Velázquez's *Las Meninas*. They are caught in awe, they are speechless and just at that instant of time are drinking with their eyes what seems to them to be unutterably beautiful."[14] This investment in the aesthetic would be complicated by Salvador Lopez, who was president of the university from 1969 to 1975. In the much-referenced essay "Literature and Society," he would tease out a tendency in the Philippine art world to reduce art to itself, an orientation that was in his words the "mark of a decadent generation, advanced and defended most stoutly by those who have irretrievably lost something of the vitality of nature through vicious self-indulgence or by those who have been tainted in the blood by some inherent vice."[15]

In this interplay of quotes on the sublime and the decadent, the study of critique by Wendy Brown, in conversation with Reinhart Kosseleck, is enlightening, specifically in the way she formulates a notion of critique by way of its provenance in the Greek term *krisis*, which is a kind of deliberation to restore order in the polity, "a tear in justice through practices . . . exemplary of the justice that had been rent."[16] This desire for order to redeem the polity testifies to the deconstructive interest of critique, a gesture that cannot totally elude, though is able to transform, its object, with the critical agent in the Foucauldian sense resisting being governed "so much" and in a particular way. The object, like art history, for instance, is reinscribed or refunctioned in the "impossibility of a full undoing,"[17] a fraught procedure in which alterity ceases to be an alienated otherness or irreducible difference. It rather gathers and accretes from instances of imitation and intimacy, kinship and intimation in response to a "sudden vicinity of things"[18] and other people in time and discrepant places. In her ethnography of a Philippine peninsula, the anthropologist Fenella Cannell refers to a wistful moment in the tropics in which an aspirant in a singing competition croons "Autumn Leaves"

with so much feeling that the meaning of the utterance survives the foreign so that it could anticipate the future: "In singing a song part of whose meaning escapes one, one evokes, among other losses, the sadness at not having completely understood, at being excluded in relation to a cultural register which, if one masters it, can open the doors of possibility and change one's life."[19]

Representation

A symptom of art history's crisis is its expansionist remediation to rectify an egregious exclusion. For instance, in the attempt of an institution like the Guggenheim Museum in New York to widen its parameters of the notion of the global, it launched in 2012 a global initiative by "representing underrepresented regions" like Southeast Asia.[20] This claim occasions a question: Is the region a precondition to representation and must representation be conceived exclusively in terms of a collection in a museum? Is the region a basis of comparison and translation? But what categories might be set up to enable us to compare and translate through the levels of locality that contrive the region? Finally, what does it mean to be sufficiently represented and surmount the condition of underrepresentation by way of a critical mass of representation? What level of critical mass of representation should or could be achieved?

At the other end of this pole is a surplus of representation undertaken by a curatorium of twenty-seven as seen in the 2013 Singapore Biennale, a venture severely afflicted with the anxiety to recognize the place and presence of Southeast Asian artists across uneven modernities and modes of engagement with the global contemporary. This overinvestment in representation may stand at variance with the utter indifference to history in Singapore, the most affluent Southeast Asian nation-state that possesses the most extensive collection of the art of the region. As T. K. Sabapathy points out: "There is little or no interest in history in Singapore because to remember is to impede being fully in the present and to thwart moving forward. To pause over the past is to be intolerably encumbered, to dwell on yesterday is profitless indulgence and to think historically is to sink into pitiable paralysis."[21]

Southeast Asia is one such region of contestation. It was previously quite vast, sprawling across the Austronesian geography. But it was geopolitically constricted in the 1960s by way of the Association of Southeast Asian Nations (ASEAN, founded in 1967) that in the present seeks to more fully integrate the region within a "market-driven economy" and a "movement of skilled labor and

talent."[22] Such a plan has shaped current initiatives of school systems in Southeast Asia to standardize their general education or liberal arts programs in light of efforts to put in place an ASEAN Community not dissimilar to the European Union.

The methodologies of art history to constitute this region implicate the crisis of art as a rupture in the formation of a colonial and postcolonial polity. First, there is the investment in comparative modernity, with the nation styled as the context par excellence of a highly mediated modernity only to become part of the woodwork of a region nominated as Southeast Asia or Asia. Then, there is the turn toward the ethnographic in the absence of a deep and dense archive of art-historical material; and a reconsideration of art history and the "aesthetic attitude" not as a study of privileged objects but rather as, in the words of Stanley O'Connor, who has mentored many specialists in Southeast Asian art history at Cornell, "rooted in social customs concerning death and a speculative investigation into the nature and the destiny of the soul."[23] And finally, there is the reflexive postcolonial contemporary shaped by the dialectic around tradition and change, temporality and cosmology. This is exemplified in how, for instance, Australia through the Asia-Pacific Triennial, beginning in 1993, insinuates itself and the world's longest-living culture of indigenous peoples in the continent into the rest of Asia to constitute the hyphenated rubric of Asia-Pacific.[24] It is also in the postcolonial contemporary in which the artist ponders the history of art as a burden and an opportunity to demonstrate mixture and mastery.

Redza Piyadasa's mixed-media work titled *Entry Points* (1978; fig. 4) assimilates a 1958 painting by Chia Yu Chian titled *River Scene* into an otherwise bare canvas, stained only by trickles of paint, a broken border, and the stenciled sentence that disfigures the scene of

Fig. 4. Redza Piyadasa (Malaysian, 1939–2007), *Entry Points*, 1978. Mixed media, 39 3/8 x 30 3/4 in. (100 x 78 cm). National Visual Arts Gallery of Malaysia (Balai Seni Visual Negara), Kuala Lumpur (1979.004). Koleksi Seni Visual Negara

Fig. 5. Gede Mahendra Yasa (Indonesian, born 1967), *7 Magnificent Masterpieces #1*, 2013. Chinese ink on paper mounted on canvas, 78 3/4 × 59 in. (200 × 150 cm)

painting: "Art works never exist in time, they have 'entry points.'" The line tracks the modernity of art in terms of trajectories, not origins; transpositions, not lineage or linearity. The idea that the work of art is approached through "entry points," as opposed to having a fixed temporal existence, skews the history of modernity, most particularly its self-fulfilling prophecy of progress. In Bali, when Gede Mahendra Yasa intuits contemporary form, he is seduced by two visions: the vision of Balinese painting that has controlled the idyllic conception of Bali and the vision of Western art, specifically American modern art. In an attempt to overcome the antinomy sustaining those binary visions, he transposes the techniques of Balinese painting to simulate the effect of so-called Western modernism (fig. 5). The result is a mimicry of the Western and the mastery of the Balinese, an overinvestment in the production of surface almost on the level of obsession and devotion related to craft and ornament. It also references the viable commerce of painting in Bali that simulates Western style and corrupts the local expression. In his Jackson Pollock series in 2011, the Abstract Expressionism effect is faithfully depicted but in a mode so graphic that it negates the gestural impulse of the style (fig. 6). A similar scenario is reprised in his Robert Ryman series in 2008 in which he represents whiteness photorealistically through calibrated contrast and careful chiaroscuro and not conceptually as object. In the face of this painstaking

Fig. 6. Gede Mahendra Yasa, *Rorschach #1A*, 2013. Acrylic on canvas, 34 × 53 $^7/_8$ in. (86.5 × 137 cm)

and elaborate project, we cannot help wondering about the necessity of the time-consuming labor and consciousness and harboring the mixed feelings of sadness and the sublime. The critic Enin Supriyanto, who describes this temper as "post Bali," argues that what Mahendra Yasa seems to ask is this: "What is the meaning of painting today if all the techniques, materials, styles, as well as iconographies present can be very easily reinstated on a canvas through realism and appropriation without requiring thought processes or subjective aesthetic considerations?"[25]

Alterity

Some remarks on the history of art as a history of the post-colony round out this reflection. One trajectory in this regard is the Asian-African Conference held in Bandung, Indonesia, in 1955 that contemplated a nonalignment away from the bipolar struggle between the United States of America and the Soviet Union. The Indian theorist Geeta Kapur, in conversation with this conviction, sets up this argument: "The term avant-garde in its ever-renewed use must be linked to a discursive 'method' where retrospective, annotative, and projective art history does not so much 'fill the gaps'; it dares to begin with art practices from elsewhere: as, for example, from the Third World, now more commonly understood as the (global) South."[26] In this intervention, Kapur tries to reactivate the political energy of a Third World international by stirring up the memory of Bandung and the commitment "to building a distinct political identity not based on civilizational hubris or universal humanism, but on unembarrassed alterity and an experimental but inescapable 'truth' of becoming—a rigorous form of selfhood in revolutionary, rather than civilizational terms."[27]

This compelling plea from Kapur may be translated as a call for an alternative art history. Such an imagined alternative is the second moment of critique. Advanced here is a possible third moment through the concept of an art-historical alterity instead of an alternative art history. This reflection is drawn to alterity because it instantiates a deconstructive procedure and at the same time insists on why the post-colony must cherish its difference in order to resist assimilation as an alternative to settling into some kind of province, or a rearticulation of an ideal and a prejudice.

It is often assumed that alterity is a contingency, with the latter term, *contangere*, defined as contact and contiguity. It could, however, be characterized as a tangency, one that is barely touching, and in the language of mathematics, differential. Central here is the 1887 Spanish novel by the Philippine national hero, Jose

Fig. 7. Cover of *Noli Me Tangere* by Jose Rizal, 1887

Rizal, *Noli Me Tangere* (fig. 7), which means Touch Me Not, taken from the biblical scene in which Mary Magdalene is about to touch the risen Christ, whom she initially misrecognizes as a gardener, who stops her, saying that he has not yet ascended. In Rizal's novel, the hero, Crisostomo Ibarra, who had lived in Europe, returns to Manila. When he passes by the botanical garden, he is troubled by a double vision: of an empire flourishing and of a colony withering away.[28] Rizal submits the phrase "el demonio de las comparaciones" to explicate this moment. It has been translated by the historian Benedict Anderson as "the specter of comparisons." But the Philippine novelist Patricio Mariano offers the more inflected translation, "ang tukso ng paghahawig-hawig," that in English reads "the temptation of semblances" or the "enchantment of affinities." Instead of the crisis of the post-colony being framed within contingency, it can be grasped in terms of a tangency in which the mediation of art is confounded by hallucinations of comparisons, semblances, and affinities.

The French thinker Jean-Luc Nancy has written a book on the concept of the *noli me tangere*, building on the image of Correggio, among other images of the same subject, of the biblical scene (fig. 8). Rizal had seen the same painting at the Prado in Madrid when he was in Europe in the nineteenth century. For Nancy, this incident exemplifies the figuring of the sensitive, the sensible, the sensory, or the sensual by way of the biblical injunction of untouchability. He locates the untouchable "wherever there is withdrawal, distance, distinction, and the incommensurable."[29]

Fig. 8. Antonio Allegri da Correggio (Italian, 1489–1534), *Noli me tangere*, ca. 1535. Oil on panel, 51 ¹/₈ × 40 ¹/₂ in. (130 × 103 cm). Museo Nacional del Prado, Madrid. P00111

Fig. 9. Juan Luna (Filipino, 1857–1900), *España y Filipinas*, 1886. Oil on canvas, 98 × 31 ¹/₂ in. (248.9 × 80 cm). Lopez Museum and Library Collection, Pasig, The Philippines

In Jose Rizal's imagination, the title *Noli Me Tangere* refers to a social cancer that should not be touched because it will fester and ultimately disseminate. In relation to the theme of crisis, it is, in the study of Reinhart Kosseleck, "a critical condition" that demands urgent deliberation, a critique. Rizal, being a medical doctor, diagnoses the colonial in terms of a cancer, a malady festering across the centuries. It is through the novel, as expressed in the dedication, that he seeks to "lift partly the veil" that hides the ills of the colonial system and to finally expose the truth. In the mind of Rizal and Nancy, the body is raised to be lain bare. In Nancy, it is regarded as an *anastasis*,[30] or resurrection, or better perhaps, an insurrection (or an insurgency and not just an emergency) if we wish to make it co-extensive with the political postcolonial or the postcolonial political. In Rizal, it inevitably suffers in *metastasis*, a radiation of unbearable affliction. The untouchable body, therefore, is a body in a particular stance, in a critical condition, a body of critique, crisis, and emergency/insurgency.

It is proposed that the postcolonial mediation of the crisis of beholding the body of art is not a contingency but a tangency. And this could possibly be evoked by the painting of Juan Luna, the Philippine painter who received one of the gold medals at the Madrid Exposition in 1884, a triumph that prompted Rizal to exclaim that "genius knows no country . . . it is like light, air, the patrimony of everybody, cosmopolitan like space."[31] The work *España y Filipinas* (Spain and the Philippines) was painted the year before Rizal's novel came out (fig. 9). As in Correggio's

Fig. 10. Cover of *Exposición Regional Filipina*, 1894. Lopez Museum and Library Collection, Pasig, The Philippines

painting, conjured here is a moment of ascension, with the allegorical figure of Spain guiding the figure of the Philippines into the light of colonial civilization and progress. The same image was on the cover of the catalogue of the 1895 *Exposición Regional Filipina* (fig. 10), which presented the various fruits of Philippine labor under the aegis of Spain in terms of art, industry, and commerce. A version of this work at the Prado Museum is said to have been commissioned for an overseas museum and library in Madrid, with Luna's sensibility supposedly having been informed by the *Exhibition of the Philippines* in Madrid in 1887.[32] This iconography of ascension to enlightenment would be reanimated, or better still, find allegorical incarnation, in future propositions for obelisks to Jose Rizal himself, as can be observed in several entries (figs. 11, 12) to an international competition (1905–7) for a national monument (fig. 13) and an existing one in the town of Palo in Leyte (fig. 14). Indeed, this is an allegory of perfectability and progression, with Filipinas achieving ideal and material status as consciousness and labor in the world, forever indebted to the path and patronage of Spain.

There is in this picture tangency, translated as a sense of intimacy and also of becoming an intimate or kin of the foreign, and the aspiration to equivalence through the processes of mixture and mastery as embodied by the life of the painter Luna, the native who was honored in the European salon, and the afterlife of the colony, which became the first republic in Asia in 1896 after its revolution against Spain. How the hand of Spain erotically, and therefore queerly, touches the waist of the Philippines, and how their faces that slightly mingle are set apart

Fig. 11. *Noli me tangere*, entry no. 1 in the competition for a Philippine national monument, 1905–7. 16$^{1}/_{2}$ × 28 in. (41.9 × 71.1 cm).

Fig. 12. *Noli me tangere*, entry no. 16 in the competition for a Philippine national monument, 1905–7, with inscription on the base: "Dios na ha faltado á los otros pueblos,/tampoco faltará nuestro: la causa de Dios/es la causa de la libertad. 16$^{1}/_{2}$ × 28 in. (41.9 × 71.1 cm).

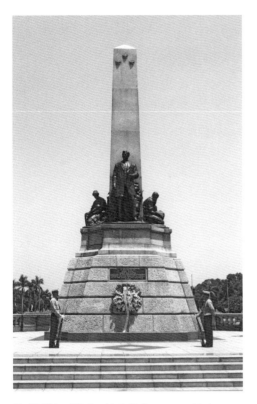

Fig. 13. Richard Kissling, *Motto Stella*, monument to Jose Rizal, 1913. Rizal Park (Luneta), Manila

Fig. 14. Monument to Jose Rizal, Palo, Leyte

by the slit of light from the distant illumination testifies to the mediation of the crisis of history, of pedagogy, of art, and of enlightenment, one that deserves a method of sympathy and urgency to more cogently elaborate on both misrecognition and belief. This is *noli me tangere*, hovering between Nancy's and Rizal's departing and disseminating body. The history of art in the post-colony is formed and then slips away in the apprehension of contact, in the alterity of an emergent, insurgent corpus.

1. Geronimo Velasco, *Toward Energy Self-Reliance: The Philippine Response to the Oil Crisis, 1973–1980* (Manila: Geronimo Velasco, 1981), 1.

2. Velasco, *Toward Energy Self-Reliance*, 8.

3. See Marc Williams, *Third World Cooperation: The Group of 77 in UNCTAD* (London: Pinter Publishers, 1991).

4. Ferdinand Marcos, "Manila and the Global New Society," in *Manila Declaration and Programme of Action: Report on the Ministerial Meeting of the Group of 77, Manila, 26 January to 7 February 1976* (Manila: Department of Foreign Affairs, 1976), 77.

5. Marcos, "Manila and the Global New Society," 3.

6. Imelda Marcos, "Between Two Worlds," in *The Compassionate Society and Other Selected Speeches of Imelda Romualdez Marcos*, ed. Ileana Maramag (Manila: National Media Production Center, 1973), 57–58.

7. Gayatri Chakravorty Spivak, "Scattered Speculations on the Question of Value," in *In Other Worlds: Essays in Cultural Politics* (New York: Methuen, 1987), 155.

8. Philip Rawson, *The Art of Southeast Asia: Cambodia, Vietnam, Thailand, Laos, Burma, Java, Bali* (New York: Praeger, 1967); Claire Holt, *Art in Indonesia: Continuities and Change* (Ithaca: Cornell University Press, 1967).

9. T. K. Sabapathy, *Road to Nowhere: The Quick Rise and the Long Fall of Art History in Singapore* (Singapore: National Institute of Education, Nanyang Technical University, 2010), 3.

10. See Deena Burton, *Sitting at the Feet of Gurus: The Life and Dance Ethnography of Claire Holt* (Philadelphia: Xlibris Corporation, 2009), n.p. See also ongoing and unpublished research of Helly Minari and Aminudin Tua Hamonangan Siregar.

11. Thelma Kintanar, "At the Heart of the University: The Liberal Arts Tradition," in *The University Experience: Essays on the 82nd Anniversary of the University of the Philippines*, ed. Belinda Aquino (Manila: University of the Philippines Press, 1991), 123.

12. Joshua Taylor, *Learning to Look: A Handbook for the Visual Arts* (Chicago: University of Chicago

Press, 1957); Grosvenor Cooper, *Learning to Listen: A Handbook for Music* (Chicago: University of Chicago Press, 1957).

13. Josefa Lava, "A History of the Humanities Department (1951–1982)," in *Suri Sining: The Art Studies Anthology*, ed. Reuben Ramas Cañete (Manila: Art Studies Foundation, 2011), 4.

14. Josefa Lava, "There Was One Man: On the Teaching of Humanities," *University College Journal: Humanities (Special Issue)* 4 (n.d.): 4.

15. Salvador Lopez, *Literature and Society: Essays on Life and Letters* (Manila: Philippine Book Guild, 1940), 167.

16. Wendy Brown, *Edgework: Critical Essays on Knowledge and Politics* (Princeton: Princeton University Press, 2005), 5.

17. Spivak, "Scattered Speculations," 155.

18. Michel Foucault, *The Order of Things: An Archaeology of the Human Sciences* (New York: Vintage, 1994), xvi.

19. Fenella Cannell, *Power and Intimacy in the Christian Philippines* (Cambridge: Cambridge University Press, 1999), 209.

20. See http://www.guggenheim.org/guggenheim-foundation/collaborations/map/sseasia (accessed July 2, 2015).

21. T. K. Sabapathy, "The Singapore Biennale, Then and Now: An Introduction," in *Singapore Biennale 2013: If the World Changed*, ed. Joyce Toh (Singapore: Singapore Art Museum, 2013), 12.

22. See *ASEAN Economic Community Blueprint* (Jakarta: ASEAN, 2008) and *Roadmap for an ASEAN Community, 2009–2015* (Jakarta: ASEAN, 2009), n.p.

23. Stanley J. O'Connor, "Art Critics, Connoisseurs, and Collectors in the Southeast Asian Rain Forest: A Study in Cross-Cultural Art Theory," *Journal of Southeast Asian Studies* 14, no. 2 (September 1983): 408.

24. See Caroline Turner, "Cultural Transformations in the Asia-Pacific: The Asia-Pacific Triennial and the Fukuoka Triennial Compared"; and Francis Maravillas, "Cartographies of the Future: The Asia-Pacific Triennials and the Curatorial Imaginary," in *In the Eye of the Beholder: Reception, Audience, and Practice of Modern Asian Art*, ed. John Clark, Maurizio Peleggi, and T. K. Sabapathy (Sydney: University of Sydney East Asian Series and Wild Peony Press, 2006), 221–243; 244–270.

25. Enin Supriyanto, "Post Bali," in *Post Bali: New Paintings by Gede Mahendra Yasa* (Jakarta: ROH Projects, 2014), 4; available online: www.rohprojects.net/wp-content/uploads/2014/04/POST-BALI_ecatalogue.pdf (accessed August 28, 2015).

26. Geeta Kapur, unpublished, "Recall as Reflexion: Critical Annotation of a Moment in Mid-Twentieth Century History," remarks delivered at the Guggenheim Museum's 4th Asian Art Council meeting, Bangkok, 2014.

27. Kapur, "Recall as Reflexion."

28. Jose Rizal, *Noli Me Tangere* (Manila: Bookmark, 1996), 67.

29. Jean-Luc Nancy, *Noli me tangere: On the Raising of the Body* (New York: Fordham University Press, 2008), 14.

30. Nancy, *Noli me tangere*, 18.

31. Quoted in *Zero-In: Private Art, Public Lives* (Manila: Eugenio Lopez Foundation, Inc., Ayala Museum, and Ateneo Art Gallery, 2002), 74.

32. Carlos Navarro, "La decoración de Juan Luna y Novicio para el Museo-Biblioteca de Ultramar: las obras conservadas en el Museo del Prado y sus modelos formales," in *Revista Española del Pacifico* 19–20 (2006–7).

The Value of Art

Manuel J. Borja-Villel

Each generation considers its own time to be the beginning or the culmination of a historical process. But today's society, determined to consume itself in a continuous present, appears oblivious to both past references and future projections. Unlike other periods, our age defines itself in posthistorical terms. We talk about postmodernity, post-Fordism, postcolonialism, and even postdemocracy: a world without yesterday or tomorrow, in which there is no room for alterity or for antagonism and any difference ultimately comes down to a matter of style or fashion. We find ourselves trapped in the moment of the commercial transaction, immersed in an illusion that, as Jonathan Crary argues in his book *24/7*, sets up a false equivalence between that which is accessible, available, or usable and that which exists.[1] This situation inevitably leads to the impoverishment of our cognitive and affective faculties.

On the cultural front, this lack of historical perspective has gone hand in hand with an emphasis on reception over production. Michel Foucault and Roland Barthes pronounced the "death" of the author, or rather, the author's replacement by the reader/spectator as the central factor in the artistic phenomenon.[2] Accordingly, the creative act came to be seen as the work of compiling, associating, and assembling pre-existing works. Art became reflective, probing its own nature and pushing the spectator to constantly judge what was and what was not art. In the 1980s and early 1990s, members of the so-called Pictures Generation and artists associated with the Institutional Critique embodied this position in an exemplary way. They appropriated recognizable images from the history of art, drew upon the new sources of popular culture, and devised works in which the analysis of images was linked to a questioning of representation and devices.

This speculative trend has been one of the guiding principles of modernity since Duchamp. But the distance that previously existed between the spheres of aesthetic experience and economic activity no longer stands, because knowledge and our own subjectivity now play a privileged role in the value production system. This is the difference between the modern and contemporary worlds. The dilemma today is not just about discerning whether something is art, but about elucidating what aspects of our environment are not art. In the 1990s, artistic

Fig. I. Marc Pataut (French, born 1952), *Dimanche 15 mai 1994—Saint-Denis/Grand Stade—Cornillon Nord/Éliane Branet, Guy Colle, Séléna et Natacha devant leur maison (Sunday May 15, 1994—Saint-Denis/Grand Stade—Cornillon Nord/Éliane Branet, Guy Colle, Séléna and Natacha in Front of Their House)*, from the series *Le Cornillon—Grand Stade (Saint-Denis)*, 1994–97. Chlorobromide print on paper, set of 316 photographs, image 3 1/2 × 4 3/8 in. (9 × 11 cm). Museo Nacional Centro de Arte Reina Sofía, Madrid

interest shifted toward more processual and community-based practices, in which artworks surrendered their autonomy and incorporated mechanisms and concepts that were often linked to disciplines such as anthropology, sociology, or therapy. In trying to change our understanding of life, these works challenge inherited notions and suggest new modes of relation. They are not utopian in the literal sense, nor do they aspire to the emancipation of a collective subject. They do not have a predefined objective, given that the imagined community is still to come into being, and their ongoing existence is in document form (photography, film, text). A paradigmatic example would be the work that Marc Pataut carried out for more than three years (1994–97) in the area where the Grand Stade de France was built, on the outskirts of Paris (fig. 1).

According to the modern canon, all art aspires to the purity of its own species: painting must be pictorial, sculpture sculptural, and so on. When works are classified according to their discipline, each must remain in its place, in its class, carrying out the function that corresponds to it. More recent art, however, tries to bring about a hybridization between techniques and media. It incorporates texts, images, and stages; it tends toward the theatrical; and it is most commonly expressed in the form of an installation in which audiences do not remain passive, but must navigate through it, reconstituting it and making it their own. Spectators presumably choose the aspects that interest them and form their own image of the work, which is not necessarily in agreement with that of other spectators or even with that of the author. Similarly, spectators are not expected to take in everything in an exhibition: videos and documents can be watched and read later, at home, at the studio, or in the office. There is no single artistic experience in postmedia art, but rather a multiplicity of experiences. All interpretations, be they collective

or individual, are always fragmentary or partial. Contemporary theatricality lacks a totalizing drive and differs from Wagnerian *Gesamtkunstwerk*.

Today's art is performative. Its meanings unfold when it is "interpreted" by the audiences that gather around it, and they are no longer identical and self-enclosed, but emerge from encounters and tensions between the different formulations and situations. This intensifies the potentialities of individuals, allowing them to exercise control over their own bodies and actions. Nonetheless, one of the problems of contemporary art lies in the self-interested confusion between activity and agency. While activity does not radically change our way of being and thinking, agency entails a reinvention of relations as well as constant learning and an understanding of the fragility of life. For years, in our programs and exhibitions, we have been striving to secure the assiduous participation of an audience made up of committed users, to the point that passive spectators came to seem unacceptable. There was a shift from the work and its ownership, to the use or uses of the work. But in the society of the cognitariat, use does not guarantee agency, nor is there any guarantee that it won't end up becoming an empty gesture. While installations and postmedia art require a certain commitment from audiences, they can also entail the spectacularization of the artistic phenomenon and the resulting adherence to market logic. This is why—as Rosalind Krauss, following Walter Benjamin, pointed out[3]—the anachronistic, which requires a point of view in regard to the present, is an element of resistance in this context: it runs counter to the idealization of novelty and technique.

It is significant that contemporary aesthetics takes an interest in education and "useful" art, that is to say, in applied art that seeks to change communities from the inside rather than the outside, and that functions as a mechanism for mediation among different social sectors. Given the crisis of the institutions and of traditional ways of doing, and given the almost all-encompassing power of the market and of communication industries, this practice offered an alternative: it was to generate uses that are resistant to absorption, to enable what Michel de Certeau called the proliferation of anonymous, perishable creations that allow people to stay alive, and to overcome the dichotomy between high art and popular culture.[4]

Art helps us to change the way we perceive the world, and to reassess our hierarchy of values. Although this is important at any time, it is particularly vital during a period of systemic crisis such as the one we are living through now. One of the problems facing today's art is the fact that aesthetic experience is often co-opted from the start. Now more than ever, in order to be effective any artistic

action must generate fields of dissent and favor the mobilization of anonymous people. Art that is overly useful, that advocates consensus, runs the risk of becoming a new kind of idealism, or a simple excuse to open new markets and at the same time abolish any likelihood of rupture. The *Homeless Vehicle* (1987–89) by Krzysztof Wodiczko very quickly came to be seen as a milestone of artistic activism because it clearly showed the necessary (non)usefulness of contemporary art (fig. 2). Wodiczko did not intend this object to become a habitual product in everyday life, nor to bring into being a predefined society. On the contrary, the image of hundreds of vehicles being pushed along the streets of Manhattan by homeless people drew attention to the dystopian reality of a world in which we are increasingly strangers to ourselves. Even though it was a very critical, cutting response to the neoliberal policies of the Reagan administration in the United States,[5] the *Homeless Vehicle* was not a prototype designed to create a "better world." Instead, it was devised as a mechanism by which to question and overcome the unbearable reality of a present that has become unrecognizable to us.[6]

Fig. 2. Krzysztof Wodiczko (Polish, born 1943), *Homeless Vehicle, Variant 5*, c. 1988. Aluminum, fabric, wire cage, and hardware, 60 × 36 × 56 in. (152.4 × 91.4 × 142.2 cm). ©Krzysztof Wodiczko, Courtesy Galerie Lelong, New York

Art has a clear political dimension. Over the past few years, close ties have sprung up between museums and real estate development, culture and financial capital, art and communications industries. The forms of organization, frameworks, and strategies used by different cultural entities undoubtedly reflect specific distributions of power. There is no direct transmission, however, between the estrangement provoked by today's art and social mobilization. When art aims to anticipate the effects of its actions, when it offers solutions and answers instead of uncertainties and questions, when it takes the guise of success rather than failure, it changes into a rhetorical figure, a new form of aestheticization. The confusion over (not really) useful art comes from the failure to understand the artistic phenomenon as an enigmatic signifier: from not recognizing the materiality and even the opacity of the work of art, and the fact that its complexity and negativity serve to create spaces that resist absorption. We have not progressed from aesthetic shock to political intervention. We have gone, as Jacques Rancière would say, from one sensible world to another sensible world that establishes a different set of tolerances and intolerances.[7]

———

Art has always maintained an ambiguous relationship with power. It is this same ambiguity that has allowed it to elude utilitarian reasoning, or the various types of instrumentalization to which it has been subject throughout history. A religious painting by Caravaggio or a royal portrait by Velázquez had both an educational and a symbolic function (figs. 3, 4). But they are also in themselves an enigmatic signifier; a relational element that encourages different approaches, provokes a great variety of meanings, and complicates and impedes their absorption. In the same way, even if conservative factions of bourgeois society were suspicious of the artistic avant-gardes, their transgressive proposals did come to be tolerated over time, provided that such limits were confined to very concrete discursive and institutional limits. The museum was one of these enclosures. By separating works from their historical and social reality, it constituted a place of privilege in which antagonism and diversity became affirmative through a process of canonization, aestheticization, and even inversion of its meanings. The institutional criticism that some artists deployed in the 1970s opposed this assimilation, attempting to create fissures and spaces of resistance in the system itself.

Fig. 3. Michelangelo Merisi da Caravaggio (Italian, 1573–1610), *Calling of Saint Matthew*, c. 1599–1600. Oil on canvas, 122 ³/₄ × 133 ⁷/₈ in. (322 × 340 cm). Contarini Chapel, San Luigi dei Francesi, Rome

Fig. 4. Diego Velázquez (Spanish, 1599–1660), *Philip IV*, c. 1653. Oil on canvas, 27 ¹/₄ × 22 ¹/₄ in. (69.3 × 56.5 cm). Museo Nacional del Prado, Madrid. P01185

In recent decades, modern art has been subject to all kinds of pressures that have led to its transformation into a commodity and the consequent loss of its critical nature and its utopian anticipation. As Benjamin Buchloh said, in an article published in *Artforum* several years ago, radicalism has been converted into its opposite, a condition of universal aesthetic entropy.[8] The 2013 edition of *Unlimited*, at the Basel art fair, was a good reflection of this attitude: decontextualized pieces, short videos, and a grandiloquence reminiscent of the *art pompier* of the nineteenth century. A gigantic *Bicho* by Lygia Clark, situated at the entrance to the pavilion, was palpable evidence of how the sharpness of a brilliant artist had been transformed, in the hands of an unscrupulous market, into a joke in bad taste. The aesthetic experience is no longer a liberating experience, an opening up of new worlds, but rather the ratification of the status quo. Artistic practice has been assimilated into the culture of consumption and, due to the growing precariousness of criticism, the parameters of evaluation and distinction are fading in an alarming way. The result is this "anything goes" that is so popular in some sectors of contemporary art. These sectors perceive the existence of a judgment or discursive suggestion as an aggression against a supposed aesthetic pluralism, which is another manifestation of this advanced capitalism that reduces any artistic expression to an indifferent and interchangeable product.

Over the course of just a few months, approximately 700,000 people visited the retrospective exhibition of the work of Salvador Dalí that the Museo Reina Sofia organized in the spring of 2013. Many of them put up patiently with having to queue for more than two hours to be able to visit the rooms (fig. 5). Together with *Picasso, Tradition and Avant-Garde* and the exhibition dedicated to Antonio López, this Dalí show will be our most popular by far. It belongs in the line of exhibitions dedicated to Velázquez and Monet at the Prado, or to Hopper at the Thyssen, to mention just some of those that have taken place in Madrid in recent years. What is it that makes these artists so popular, so appealing? What does their popularity consist of? Although a number of factors come into play, there are two that stand out in the case of Dalí. The first is connected with the implosion of the art market that has converted modern art into a refuge value, reaching prices that were unimaginable a few decades ago. Logically enough, economic investment is clothed with enormous communication campaigns that move people to internalize the offer of the spectacle as a need. The authors and their works are converted into brands for products of rapid consumption. Dalí, like Picasso, Miró, Van Gogh, Monet, and others, forms part of an imaginary universe

Fig. 5. Line for Salvador Dalí retrospective *All of the poetic suggestions and all of the plastic possibilities* (2013) at the Museo Nacional Centro de Arte Reina Sofía, Madrid

of creators that we know and in whom we recognize ourselves. Secondly, Salvador Dalí set a precedent for Warhol in his perception of the central role that the mass media had acquired in contemporary society. Both understood that it is the communications industries that determine our subjectivities and had no hesitation in exploiting their resources to the point of fever pitch. If, over the course of the nineteenth century, instrumental reasoning (the use of reason with the ultimate aim of gaining a benefit) took the place of historical reasoning (reason as an element of liberation), we might conclude that populist reason is hegemonic in these moments. This is characterized by the desire to direct our attention to what is exempt from interest and to introduce to us as something new that which we have already had our fill of seeing time and time again.

There is no doubt that the current crisis is serious and systemic. But it is not the first and it is unlikely to be the last that will affect us, given that crisis is consubstantial with the dynamics of capitalism. Since its birth, capitalism has gone through regular mutations that drive its constant reinvention and growth.

What makes today's situation different from other periods is the fact that the crisis seems to be rooted in fear and conformism, in what has already been described as the "aesthetics of recession," which has to do with the unstoppable desire to adapt to the times.[9] When we feel that we are in debt to a particular system, when we are burdened with the weight of maintaining the status quo, artistic production becomes desperately mimetic and derivative. Adaptation is the logic of survival, which is the enemy of self-realization. If artists acquiesce to the situation that they find themselves in, their work becomes finite, impotent.

Melancholy leads us to imagine that if we stop, the rest of the world does too. But recession is not synonymous with paralysis. Recession and expansion are communicating vessels: stagnation in one area usually goes hand in hand with expansion in another. In this sense, the balance between critical culture and the market, which was characteristic of Western art since the 1960s, has recently inclined toward the latter. Whereas the market had been the material condition of art, it has now become its symbolic condition, determining not only our perception of the world but also our hierarchy of values, and at the same time merging the public sphere with the world of advertising. The assurance with which the art market and the communications industry have established themselves in the powerful Asian world confirms that tendency.

It is clear that we lack the strength to overcome the crisis. We must first reconfigure our boundaries and organize supranational spaces that allow us to confront a market that operates at a global scale. Most museums and cultural institutions, however, operate within a national framework. This scale still defines many of us, and it reflects a canonical, closed idea of identity. Never before has it been so necessary to question a system that condemns us to inoperativity.

We know, however, that power is not to be found outside of society, in a court of superior standing, but that it is rather submerged within the framework of our personal relationships. That these are objectified and rendered meaningless is related to a collective order that brutalizes us, and in doing that takes advantage of us. A world of consumers is organized by impulses similar to those of the masses as described by Elias Canetti, very different from the multitude that occupies the squares.[10] At the heart of the masses, the excited individuals who constitute it do not make up a public as such. The mass is a nonreflexive amalgam, composed of semi-subjectivities, of people without a profile who unite around a leader, hero, or idol, and identify with him. Their actions tend toward submission, not emancipation.[11] Hence, there is no need for the voice of an artist or an intellectual who

questions their world. He has a clear sense of what he wants and does not need an external judgment to call it into question. Any judgments and contrary opinions are always perceived as a danger and raise all kinds of suspicions.

The modern artist and the modern intellectual freely represented the kind of universal consciousness that was opposed to those high places that were in service of the state or of capital. Their freedom proceeded from the relative autonomy of art. At present, however, artistic practice is increasingly integrated into a system in which knowledge no longer belongs to us. Our intellectual work is constantly expropriated, and our own experiences are now susceptible to being transformed into merchandise. The porosity between critical approaches, the activity of the intellectual, the artist, and that which the communications industries promote becomes more intense every day, in some cases reaching levels of cynicism and perversity that were unknown until very recently. When our years of research, funded by public money, end up being the subject of speculation in private hands, we realize, unfortunately, that our work is helping to establish the thing we criticize. In addition, when we wish to generate spaces managed and financed on the margins of the state, we start to have doubts about whether or not we might be participating in the general privatization that advanced capitalism advocates, assuming a task and responsibilities that the state does not want to exercise because they are not considered profitable.

The role of the cultural producer can no longer be that of situating himself or herself either "a little in advance or just outside" in order to show truth to the rest of humanity. It is a question of struggling against forms of power where this is at once object and instrument: in the order of "knowledge," "truth," "consciousness," and "discourse." As Foucault reminds us, power and the market are organized on the basis of a network of influences and relationships that are global and total. Faced with this practice, there arises the need for responses that are fragmentary and local. "We have no need to totalize that which is *invariably* totalized on the side of power; if we were to move in this direction, it would mean restoring the representative forms of centralism and a hierarchical structure."[12] So, if there is something today that unites the artist, the critic, and the curator, it is the pressing need for self-reflection and the specificity of approach. Robert Filliou's *Autoportrait bien fait, mal fait, pas fait* (Self-Portrait Well Made, Badly Made, Not Made; fig. 6), whose games are beyond instrumental reason, Marcel Broodthaers's melancholic and ironic poet, or a critical author in the shape of a Hans Haacke (fig. 7) or a Michael Asher are examples of methods that break down the existing

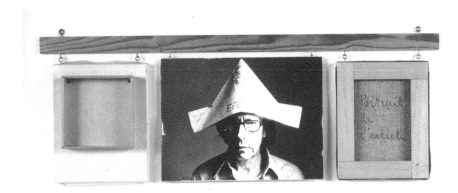

Fig. 6. Robert Filliou (French, 1926–1987), *Autoportrait bien fait, mal fait, pas fait* (*Self-Portrait Well Made, Badly Made, Not Made*), 1973. Wood, pencil, ink, black and white photograph, Overall: 13 $^3/_8$ × 37 $^1/_4$ × 2 $^3/_4$ in. (34 × 94.5 × 7 cm). Museo Nacional Centro de Arte Reina Sofía, Madrid

Fig. 7. Hans Haacke (German, born 1936), *Condensation Wall*, conceived 1963/1966, fabricated 2013. Plexiglas and distilled water, 70 × 70 × 16 in. (177.8 × 177.8 × 40.6 cm). National Gallery of Art, Washington. Gift of the Collectors Committee, 2013.44.1

barriers between the work of the intellectual, the artist, and the manager. They avoid the totalized logic of the market and come close to that which Foucault himself called "specific intellectual." And they succeed because their works are not concerned with producing value or in obtaining any accountable earnings. Perhaps therein lies the great potential for creating spaces of resistance and freedom in a society that ignores what it does not find useful, what serves no purpose.

———

The generation of a new cultural model must go hand in hand with institutional change, given that institutions are the main structures for the invention of the social, of affirmative, nonlimiting ways of doing. This is particularly important now, because governance in modern Western society is not about applying repressive measures, but about getting people to interiorize them. With the arrival in recent decades of what Luc Boltanski and Ève Chiapello called artistic criticism as a characteristic form of labor relations, the individual—in a natural, unforced way—begins to play an active role in his or her own subjection to governmental control.[13] Artistic criticism called for an authentic, nonalienating life based on creativity, and free from dependence on the boss and fixed working hours that were typical of Fordism. But at the same time, it promoted the subordination of the subject to a labor structure in which cultural producers favored their own precarization. Cultural producers sought greater freedom and flexibility at the expense of the expropriation of their work by the owners of capital, or of the legal means of dispossession: in other words, at the expense of introducing their own creative activity into the logic of the marketplace, or into forms of cultural domination that are at the service of projects based on the appropriation of public space.

It has become very difficult to defend the public institution today. The dichotomy between the public and private realms that has been the basis of social organization for the last 150 years no longer works. The creative dimension that characterizes our society can be found in both the private and the public spheres, and the difference between the two is determined arbitrarily. Casting the public sphere as the manager of creativity does not guarantee that creativity will not be expropriated for profit-making purposes. The public sphere now refers to a management regime founded on ownership, and as such its assets are transferable, even if they are more or less accessible to a large part of the population, or if they are administered by the state.

In this context, it becomes necessary to rethink the institution in terms of a communality that emerges from the multiplicity of singularities that do not form either a governmental public sphere or a private one, but one that is outside of both. To do this, it is essential to break the dynamic of franchises that appears to be so attractive to museum managers, and to think instead about a kind of "museum of the commons" of a confederation of institutions that share the works housed in their centers, and, above all, participate in the experiences and narratives that are generated around them. Only thus will we be able to say that putting the self in plural depends on my involvement in the world with others, and not on my access to the other. It is here, between self and other, that the sphere of the common comes into being. It is a sphere that differs from the public sphere, because ultimately, what is public does not belong to us. The public sphere that the state offers us merely comes down to the delegation of economic management to the political class by a collective whole. Communality is not an amplified expansion of the individual. Communality is something that is never concluded. The common sphere is only developed through the other and by the other, in a common realm, in the *shared being*, to borrow the terms of Maurice Blanchot.[14]

If the main objective of the cultural industries, and even of the art institution, is the search for the *outside*, for innovation, and for that which emerges everywhere, in order to domesticate it and turn it into merchandise, the new institutional sphere should have an open, explicitly political dimension. It should be open to that multiplicity, simultaneously protecting its interests and favoring ethical, political, and creative surpluses that are antagonistic in a shared space. It is very important to seek out legal forms appropriate to the production and promotion of what is common through network structures, rather than industrial ones. It is fundamental to get institutions to return to society what they take from it, so that what is common is not usurped by the individualities that make up that magma.

At Museo Reina Sofía we are working in several directions that seek to transform our museum into a museum of the commons:

(1) The collection does not create a compact and exclusive narrative, although it is not a hodgepodge of multiculturalism either. We think of it in terms of setting up multiple forms of relating that challenge our mental structures and our established hierarchies. We advocate a relational identity that is neither unique nor atavistic, but has multiple roots. This situation permits opening up to the other, and contemplates the presence of other cultures and ways of doing in our own practices, without fear of a hypothetical danger of loss of identity. Obvi-

ously, the poetics of relation cannot be understood without taking into account the notion of place. A dependence on the center–periphery duality no longer makes sense, and the periphery's claim on the center—so common in Spain's history—no longer holds. The relationship does not go from the particular to the general, or vice versa, but from the local to the world as a whole, which is not a universal, homogenous reality but a plural one. In it, art simultaneously seeks the absolute and its opposite, that is, both writing and orality.

(2) We are working on the creation of an *archive of the commons*, a kind of archive of archives. We are aware that "the archive" has become a recurring notion in contemporary artistic practice; a rhetorical figure that serves to group together the most disparate efforts, and is often simply a build-up of unrelated documentation. Following Jacques Derrida, we could ask ourselves whether the archive does not perhaps pose a certain risk of memory saturation, or even of the negation of the narrative. Nonetheless, in the common archive, the story or stories that its members originate are as important as the document itself. There is no fetishist desire to preserve and conserve everything, but only that which members of the community consider relevant, or that which forms part of their actions. Derrida explains that the archive is both *topos*, a place, and *nomos*, the law that organizes it.[15] In the archive of the common this law is shared; it is not instituted but instituent. It is not based on a genealogy of power, and it does not hierarchically order the knowledge of society. Its role goes further than cataloguing data and works and making it available to the community. The opinions, comments, and judgments of its users are shared, but so are the norms that order these opinions.

The common archive entails breaking with the notion of the museum as the sole owner of a heritage collection, and replacing it with the idea of a custodian of assets that belong to all of us, one that favors the creation of shared knowledge. The production of memory is social; memory is configured through the experience of remembering together. A period of general amnesia like our own, which appears to have replaced an era in which history was omnipresent (the era of national and imperial delusions), needs productive memory more than ever. It is important that these stories spread and multiply as much as possible. While our society's economic system is based on scarcity, which allows art objects to reach exorbitant values, the common archive is based on excess, on an ordering that defies countable criteria. In this case, the person who receives stories is certainly richer, but he who gives (recounts) them is no poorer.

(3) Lastly, Museo Reina Sofía is involved in organizing a heterogeneous network of collectives, social movements, universities, and so on who question the museum and generate spheres of negotiation that are not merely representative. This space is produced through the recognition of these other agents—regardless of their institutional complexity—as valid interlocutors or peers when it comes to defining objectives and managing resources. Nevertheless, it is essential to leave aside conventional *a priori* notions of legitimacy—nobody can claim more legitimacy than anybody else—and the use of culture to justify ends other than this open process of construction of the common sphere. There is no doubt that all of this implies questioning the authority and the exemplary role of the museum in order to endow this collective quest with nonauthoritarian, nonvertical modes of cultural action and to facilitate platforms of visibility and public debate.

1. Jonathan Crary, *24/7: Late Capitalism and the Ends of Sleep* (London: Verso, 2013), 19.

2. Michel Foucault, *Dits et écrits, 1: 1954–1975* (Paris: Éditions Gallimard, 2001), 817–49. Roland Barthes, *El susurro del lenguaje. Más allá de la palabra y la escritura* (Barcelona: Ediciones Paidós, 1987), 65–71.

3. Rosalind Krauss, *"A Voyage on the North Sea." Art in the Age of the Post-Medium Condition* (London: Thames & Hudson Ltd., 2000), 41.

4. Luce Giard, "Introduction to Volume 1: History of a Research Project," in *The Practice of Everyday Life*, vol. 2: *Living and Cooking*, ed. Michel de Certeau, Luce Giard, and Pierre Mayol, trans. Timothy J. Tomasik (Minneapolis: University of Minnesota Press, 1998), xvii.

5. For Reagan policies as neoliberal, see Gregory Albo, "Neoliberalism from Reagan to Clinton," *Monthly Review* 52, no. 11 (April 2001); and review of Michael Meeropol's *Surrender: How the Clinton Administration Completed the Reagan Revolution* (Ann Arbor: University of Michigan Press, 1998).

6. For more on the *Homeless Vehicle*, see www.walkerart.org/magazine/2012/krzysztof-wodiczkos-homeless-vehicle-project (accessed July 5, 2015).

7. Jacques Rancière, *El espectador emancipado* (Castelló: Ellago Ediciones, 2010), 70.

8. Benjamin H. D. Buchloh, "Farewell to an Identity," *Artforum* 51, no. 4 (Dec. 2012): 253–61.

9. Yve-Alain Bois, Hal Foster, and David Joselit, "Recessional Aesthetics?," *October*, no. 128 (Spring 2009): 121–122; and "Recessional Aesthetics: An Exchange," *October*, no. 135 (Winter 2011): 93-116.

10. Elias Canetti, *Masa y poder* (Madrid: Alianza Editorial, 2010 [orig. pub. 1960]).

11. Peter Sloterdijk, *El desprecio de las masas: Ensayo sobre las luchas culturales de la sociedad moderna* (Valencia: Pre-Textos, 2005), 13–14.

12. Michel Foucault, *Language, Counter-memory, Practice: Selected Essays and Interviews*, ed. Donald F. Bouchard (Ithaca: Cornell University Press, 1977), 212.

13. Luc Boltanski and Ève Chiapello, *El Nuevo espíritu del capitalism* (Madrid: Akal, 2002).

14. Maurice Blanchot, *La Comunidad inconfesable* (Madrid: Arena Libros, 2002).

15. Jacques Derrida, trans. Eric Prenowitz, "Archive Fever: A Freudian Impression," *Diacritics* 25, no. 2 (Summer 1995): 9–63.

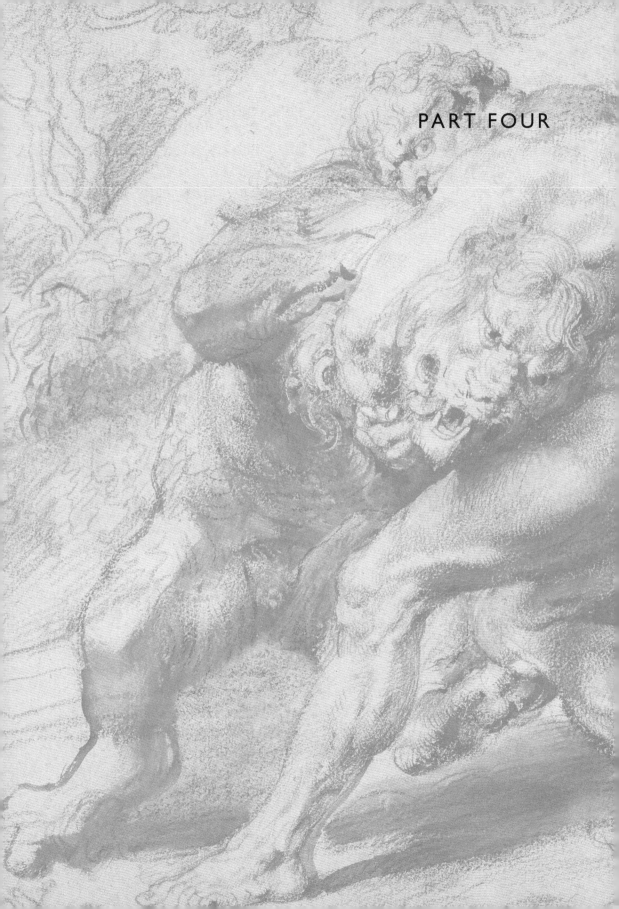

PART FOUR

EMERGENCIA

Our Literal Speed
presents
EMERGENCIA

Clark Art Institute
Williamstown, Massachusetts
8 November 2014

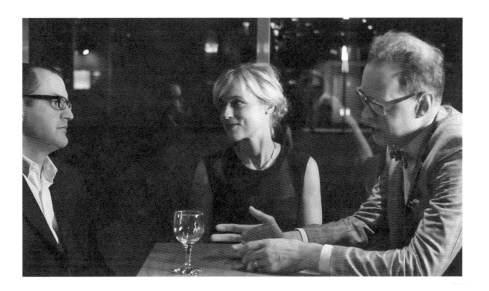

[*On screen two actors, a male academic, John Spelman, and a female development officer, Marilyn Volkman, converse in a generic space akin to a theater stage. They have just had dinner with a potential donor, Steve Juras.*]

ACADEMIC [*hesitantly*]

> Well . . . what do you think? Did we pull it off? Was I going too "hard-sell" on him at the end? I mean, do you think he—understood? I feel like I was—he never really acted like he got it.

[*Development officer checks iPhone while listening, nodding head.*]

DEVELOPMENT OFFICER

> [*still glancing at phone*] Honestly, you can never tell. [*sighs*] The ones who sit there like Buddha, they give five million, and the guys who talk all night, have all these *important* plans—you never see them again. Maybe they're embarrassed. I don't know. I think this one might come through, though. Evan's a lot younger, so he's harder to read. Like, what's his motivation?

ACADEMIC

Did I even really explain the Center for Art and Critical Experimentation? We got so sidetracked, all that random stuff he was talking; what was it—horse racing? And . . .

DEVELOPMENT OFFICER

. . . the Balearics? [*laughs*] For a few minutes there, I really thought he was talking about a band.

ACADEMIC

I mean, I don't even remember: what was I saying? [*gestures with hand*] Ya think he got it?

DEVELOPMENT OFFICER

Oh, yeah, yeah, I think, I mean, the big stuff, for sure, in the future, you can probably say a lot less. The donors usually don't want to know too much about you, or your plans—just go broad strokes—it's like Hollywood—you're telling the donors a story about themselves. and the story is more or less always the same: So, Evan, *Evan Thorpe came to love art history when he took classes with Professor X, and after he got his MBA and he went on to become CEO of Tech Company Z, he wants to give something back to the University.* It's finding the variation in that scenario that's the key.

ACADEMIC [*skeptical*]

Variation? What kind of . . . ?

DEVELOPMENT OFFICER [*crosstalk*]

Yeah, like, well . . . Evan seemed to *really* care about democracy—like it was his mom's maiden name or something. You hear how many times he said "democracy"?

ACADEMIC [*as if considering the idea*]

Yeah, you're right, he did—

DEVELOPMENT OFFICER

He was like *democracy, democracy, democracy, democracy*

ACADEMIC [*crosstalk*]

Yeah, he's, like, The Democracy *Guy.*

DEVELOPMENT OFFICER

Oh, he's soooooo into democracy. [*in Evan's voice*] "Are you into democracy the way I am?"

ACADEMIC

I am *soooo* into your democracy, Evan. [*pause*]
I really liked it when he'd look at us and say, "in a democratic society."

DEVELOPMENT OFFICER

with that face . . .

ACADEMIC

Yeah, like he wasn't sure if we really live in a democratic society or not—like, he was kinda, you know, *checking*.

DEVELOPMENT OFFICER [*goes on absently, as if to herself*]

It's like you're an air traffic controller.

ACADEMIC

Wha?

DEVELOPMENT OFFICER

I was just saying it's kinda like being an air traffic controller. . . .

ACADEMIC

Oh? Yeah? I know. You mean with Evan?

DEVELOPMENT OFFICER

Yeah.

ACADEMIC

Yeah. You've got to worry about all these side effects: if I say this, what happens?

DEVELOPMENT OFFICER

If I don't say that, what happens?

ACADEMIC

If I don't say *anything*, what happens? But you, you make it look easy. With you it flows. Like you're not even trying.

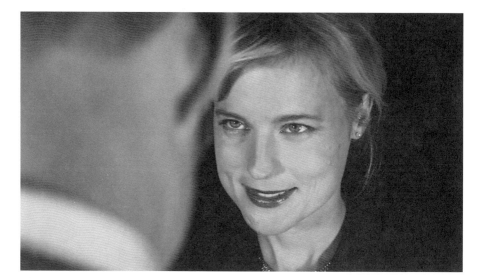

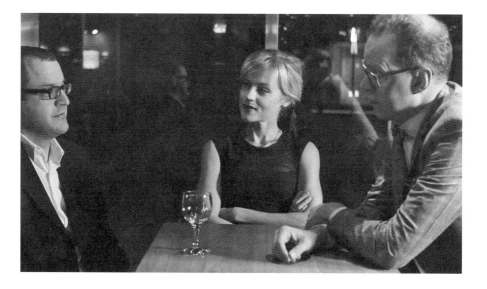

DEVELOPMENT OFFICER [*shrugs shoulders*]

It's all about listening. There's even a pose [*she does the pose*]. Sit there and smile. Rephrase what the donor says, say it back to him as a proposal, guide the conversation, add some sauce. . . .

ACADEMIC [*crosstalk*]

The truth is: I'm terrible.

DEVELOPMENT OFFICER [*cuts in*]

No, no—no, you're not.

ACADEMIC

I'm terrible—the problem—*the real problem* is I'm not upbeat. [*gestures*] Or not upbeat enough. I mean I can't be sincere AND upbeat at the same time. My thing is to be [*does air quotes*] "The Critical White Guy." I'm supposed to find [*does air quotes*] "*the contradictions in the text, the ambiguities in the visual field.*" Then, sooner or later, you find out—usually in some meeting

DEVELOPMENT OFFICER [*cuts in*]

with the associate dean or the assistant provost

ACADEMIC

exactly—that *professional metrics* and your elevator speech are the things you *really* need to worry about.

DEVELOPMENT OFFICER [*crosstalk*]

I know. That's my life.

ACADEMIC [crosstalk]

I'm getting used to it [*makes self-doubting face*], kinda, but, really, last night, oh, *that* was *not* good. I was being, uh . . .

DEVELOPMENT OFFICER [*crosstalk*]

You were fine. You were totally fine.

ACADEMIC

He got me off on, uh, Ayn Rand [*covers eyes, shakes head*] and I said, "The Dunderhead," it's just a reflex, I forgot who I was talking to.

DEVELOPMENT OFFICER

You were fine. You were fine.

[*Development officer's iPhone sounds.*]

DEVELOPMENT OFFICER
　Oh, it's the president.

ACADEMIC
　Wha? [*crazed look on face*] Obama?

DEVELOPMENT OFFICER
　University president.

[*Development officer looks concentratedly at phone.*]

DEVELOPMENT OFFICER
　Says it's an emergency. Sorry. I got to take this.

[*She leaves. Walks around in background. Distant talk on phone.*]

DEVELOPMENT OFFICER [*shutting down phone, returning to table*]
　Sorry about that.

ACADEMIC
　It's okay.

DEVELOPMENT OFFICER [*looking concerned*]
　Uhm, well, I hate to say this, but I think we *do* have a problem. Well, Evan just called the president. Apparently he, uhm, well, he has some doubts about your commitment to the [*air quotes*] "free market of ideas." Says he wants to [*making pained expression, exhales*], you know, he wants to interview other people for the director spot at the center.

ACADEMIC
　Wha? I'm not interviewing for—Wha? Hold it. Hold it. What are you talking about?

DEVELOPMENT OFFICER [*crosstalk*]
　Well, okay, I—

ACADEMIC [*crosstalk*]
　What are you talking about?

DEVELOPMENT OFFICER [*long exhale, gathering thoughts*]

I'm thinking maybe we should just go over this point by point, from the top, okay?

ACADEMIC [*shaken*]

Okay. Okay.

DEVELOPMENT OFFICER

Because I'm thinking you might have missed a step.

ACADEMIC

Okay.

DEVELOPMENT OFFICER [*brightly*]

Now you want to build the Center for Art and Critical Experimentation, right? You want to be the director of the Center and this would be a big deal for you, and for your career, and the administration's totally behind the project. And I heard your book—[*hand gestures*]—that book—your book?

ACADEMIC

Maximum Representation?

DEVELOPMENT OFFICER

No, no, I think, the other one.

ACADEMIC

Gyno-communism?

DEVELOPMENT OFFICER

[*claps hands*] Yep, Gyno-communism! [*does gang sign*] *That* was amazing. You got more retweets than the B-School [*in a sing-song voice*] popular success/critical success—and—unofficially [*glances around, whispers*]—I even heard the MacArthur's been [*does air quotes*] "getting letters." You're a big deal. They *love* you.

ACADEMIC [*reassured, crosstalk*]

Okay, yeah, that sounds, maybe, maybe you're right. As far as I know, maybe—except for the last part. [*feels better, chuckles*]

DEVELOPMENT OFFICER [*crosstalk, upbeat*]

Okay. All super. All super. Great for you. Good for us. So you need five mil-

lion as seed money to get the project, the building and all of that, to get all of that, to put wheels under the thing. But, all things being equal, it'd be a lot better to get the full fifteen million right now instead of dragging this out over three or four years. So, we agree on all of that?

[*Academic nods.*]

DEVELOPMENT OFFICER

Good. And we were banking on getting Evan to commit to a healthy chunk of that fifteen. And, you—you *totally* did the right thing tonight.

ACADEMIC

I did? *What* did I do?

DEVELOPMENT OFFICER

Definitely. Never lowball a donor. It shows respect to go too high, so you were right to go for the whole fifteen.

ACADEMIC

I said that? I don't remember saying that.

DEVELOPMENT OFFICER

Not exactly, but you kept circling back, back to that figure—I mean, it was on the table, and it should be on his mind. That fifteen million. [*pause*] So we agree on all of that?

ACADEMIC [*still a little confused*]

Sure, right.

DEVELOPMENT OFFICER [*exhales*]

Well, here's the thing, I think they already knew that Evan was good for the whole fifteen before last night. The thing is—and I just found this out myself—Evan wants to choose the director of the Center. I guess he and his money have separation issues or something. I mean this is all behind the scenes, wink-wink/nudge-nudge stuff, nothing out in the open—but he, Evan, well, he wants veto power over who's in charge of the Center.

ACADEMIC

Wha? Excuse me?

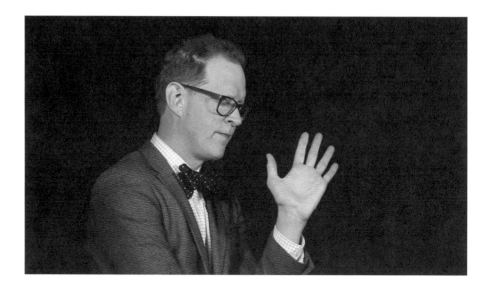

DEVELOPMENT OFFICER

Yeah, it's kind of shitty. I won't sugarcoat it. It's really shitty.

ACADEMIC

So, you're saying I wasn't pitching the Center to him last night. *He* was interviewing *me*?

DEVELOPMENT OFFICER

Yeah, you could say that.

ACADEMIC

Motherfucker. The Center was *my* fucking idea. I came up with that. I went to seven hundred fucking meetings for that. I can't remember how many times I went up the steps to the provost's office. Can you give me some point of reference, uh . . . ?

DEVELOPMENT OFFICER [*crosstalk*]

I know. I know. I know.

ACADEMIC [*pauses, looks at ceiling, then shoots a killing look at development officer*]

Who does he want to interview instead of me?

DEVELOPMENT OFFICER

I can't. Really . . . I . . .

ACADEMIC

No, who?

DEVELOPMENT OFFICER [*looks down at phone, punches some buttons*]

Deb Castro? Bob Foster?

ACADEMIC [*cuts her off*]

Bob Foster? Bob Foster doesn't know a thing about art history. He's a third-tier history department visual culture wannabe [*pauses, dumbfounded*]. He doesn't care about art history. His [*air quotes*] "distinguished lecture" was about Warhol's Soup Cans, but, like, he was talking about the soup inside the cans—explaining their ingredients and stuff. The aporia of his text? Warhol left out Beef Barley. So could you just tell me: *What is going on?*

DEVELOPMENT OFFICER [*Moves in, becomes more intimate in her speech, changes her tone, looks around the room to see who might be listening*]

Can I . . . just be honest with you?

ACADEMIC [*shaken again*]

Yes. Please.

DEVELOPMENT OFFICER

I've been doing this, I mean, I've been a development officer here at the university for almost ten years. So I can see what's happening here, maybe, in a way that you can't, because I see the same thing over and over.

ACADEMIC

I'm sure. Yeah, I'm sorry to put you . . .

DEVELOPMENT OFFICER [*crosstalk*]

No, no. It's okay. I'm not complaining. What I mean is, here's my *real* advice to you—*if you want it*?

ACADEMIC

I want it.

DEVELOPMENT OFFICER

Well, my *real* advice is: just walk away. I mean, I can tell that you don't *really* care about the Center. I think you think you *need* to care about the Center, but you don't. *The Center for Art and Critical Experimentation*? Really? I mean, come on, who came up with that? Some half-assed branding team? And, you know nobody'll want to be part of that Center, not *really*. People'll apply and jump through all the hoops to get your grants and your stipends and your fellowships, but we both know there's no *real* passion there, not from you, not from them.

[*Academic makes effort to speak, development officer waves him off.*]

DEVELOPMENT OFFICER

I mean if you care about art history; if you care about the humanities; if you care about the future of American higher education and all of that stuff—and it sounds like you *really* do; if you *really* think there's an emergency in higher ed: armies of PhDs getting chewed up and spit out, public schools in Missouri and Alabama dumping the humanities like they're nuclear waste.

ACADEMIC

Yeah, that's it. There's your broadstrokes. And—grad students? What am I supposed to say? You know—we *need* more students all the time to keep this whole thing going—it's like the housing mortgage crisis—it's an obvious pyramid scheme.

DEVELOPMENT OFFICER [*crosstalk*]

And the donors are bailing us out. They're the banks. So, if you really want to do something about it, then you've just got three choices—as far as I can tell, just three: you can rely on the state and federal governments and you'll just straight-up starve. Those people got other priorities, you know, like getting re-elected. Or you can beg rich people to give you money to [*gestures with hands*] keep all of this going, the pyramid scheme; or, and this is the big "or": or . . . you can get out there and use whatever you can get your hands on, anything, *ANYTHING*, anything that will get people to want art history half as much as they want *Game of Thrones*, or the *Real Housewives of Atlanta*, or *Grey's Anatomy*, or whatever. Let's face it, your basic problem here [*she kinda starts to lose it here, and go rogue*], you humanities people, your basic problem is that *you're* the ones living in some fantasy, some Hollywood version of academia—with floor-to-ceiling bookcases and green lamp shades. I mean, the smartest people? I mean, maybe a hundred years ago, you could say that the smartest people in the world were at universities. I just don't think you could say that now.

ACADEMIC [*crosstalk*]

You mean, Bill Gates? Steve Jobs? Facebook guy? That kind of thing . . . You mean . . .

DEVELOPMENT OFFICER [*crosstalk*]

I'm sorry. I don't mean to insult you.

ACADEMIC [*crosstalk*]

I'm not insulted.

DEVELOPMENT OFFICER [*crosstalk*]

I'm not saying your job is easy. I'm saying things are different. I don't think Roland Barthes was raising cash for centers. Panofsky wasn't pitching fundraising scripts over dinner to thirty-year-old CEOs. This is different territory.

I wish it weren't this way, but it is. I know you probably speak four languages, got an archive of facts up there [*points to head*]—I'm just saying that humanities people haven't been, well, [*exhales*] *ambitious*? Everything's always being done *to them*. *They're* never *doing it* to other people. See what I mean?

ACADEMIC

You're saying we're passive? I'm not being defensive. I'm not arguing with you. Just trying to understand.

DEVELOPMENT OFFICER

I'm on *your* side. What I mean is that you guys just don't have enough paying customers out there to live the kinds of lifestyles you want to give yourself and the people following in your footsteps.

ACADEMIC

And we're too proud, too stubborn, too self-righteous, too intelligent, to listen to people—you know, people, people . . .

DEVELOPMENT OFFICER

People like me, right? [*she suddenly yells*] "Welcome to Post-Fordist Capitalism!" [*pause*] I have no idea what that means, but I hear faculty whining about *Post-Fordist Capitalism* all the time.

ACADEMIC [*pulling himself together*]

So, you can whine to state legislators who'll never do a thing, or you can beg the donors and live with their backdoor screwing around, or you can start trying to do something about your situation by trying to do something about your situation?

DEVELOPMENT OFFICER

Yeah.

ACADEMIC [*pauses, drained, exhaling, shaking head, frustrated*]

Okay. So, according, so [*runs hand through hair*] according to what—so what, according to you—what should I do?

DEVELOPMENT OFFICER

I mean [*exhales, searches for words*] scientists fail nine times out of ten. Then they discover a cure for polio. The humanities got to be the same—you have to take more chances.

ACADEMIC [*crosstalk*]

More chances . . .

DEVELOPMENT OFFICER

You got to fall flat on your face and crash and burn. Test tubes blowing up.

ACADEMIC [*crosstalk*]

Test tubes . . . blow 'em up . . .

DEVELOPMENT OFFICER [*crosstalk*]

That kind of thing. I don't know, I'm not an art historian. I mean, my ideas will suck, but nine out of ten of them won't work anyway, but you won't find anything that works, anything that'll reach a public that'll say . . .

ACADEMIC

"I want art history the same way I want Arcade Fire"?

DEVELOPMENT OFFICER

Exactly. And if you want *that* kind of public—and I'm sorry [*points with finger*] you *have* to get it, or your students, or whoever—they *have* to get it—then you gotta work a lot harder and fail a hell of a lot more. *BUT,* if you

do that, along the way, you just might find that there're a whole lot of people out there who've been waiting their whole lives for art history to grab them and make them feel something they've never felt before. I mean, I don't know. Get a camera. Make a video. Tell the truth. Call it [*elaborate Spanish accent*] "Emergencia." Just see what happens.

THE END

A Brief Conversation on Artist-Led Administration

Theaster Gates

The following is a transcript of Theaster Gates's presentation, given after the screening of "Emergencia" by Our Literal Speed at the Clark Conference in November 2014. Gates's talk was completely restructured and improvised to respond to Our Literal Speed's film. Taking on the role of the director for the imaginary Center for Art and Critical Experimentation, the Center discussed in "Emergencia," Gates considers the current state of arts administration.

Hi everybody, my name is Theaster Gates, and I'm the director of the Center for Art and Critical Experimentation. It's wonderful that all of you have joined us today to launch what has been a very, very exciting time for us over the last few years. There's been a lot of consternation about administrative leadership and who that leader might be, and I'm really honored that I was chosen from among my colleagues by a committee of well-meaning, smart, really thoughtful trustees and corporate leaders. With their support I've come to understand that running a successful center is not just about art history, it's not just about our commitment to the humanities—it's about a deeper, richer engagement with the pulse of America. And, in attempting to have a kind of neo-Marxist slant on these issues, I want to accept that if our centers are going to live, then it's imperative that they have to live with some advanced understanding of labor and its value, an advanced understanding of intellectual inquiry in relationship to new corporate models. Otherwise, art history and the humanities by themselves will no longer survive. And I think it behooves my colleagues who are finding themselves dry bones—dry bones in a desert—if they want to regain their flesh and blood, if they want to regain the life-source of commitment to intellectual expeditions, then they would in fact have to embrace the word—the Becker Friedman [Gary Becker Milton Friedman Institute for Research in Economics, University of Chicago] word, the C-word. They will have to find themselves in situations that are uncomfortable, situations that are not like the Clark, but rather represent other kinds of centralities, ways of operating in the world, systematic imperatives. And since my talk is about how I intend to move this great Center forward, I thought I would just share with you some projects that look at my colleague, and someone who shares

my name, Theaster Gates—I thought I would examine the artist Theaster Gates in relation to administration so that we might understand not only the possibilities within emerging artistic practices but also how administration and corporation create "artistration." In fact, artistration will be the locus of my engagement.

Let's start with the question, "Well, what do centers do?" As we were trying to develop the $15 million necessary to get this Center [Center for Art and Critical Experimentation] off the ground, I reached out to the mayor of the city of Chicago. I said to him, "Mayor, the Center has the capacity to solve not only art-historical issues, but also non-art-historical issues of the city. Is it possible that with a center for a kind of new, emergent creativity, is it possible that we could address these kinds of issues?" And he said, "Well, Theaster, you know we have this problem in the African-American community. We have lots of problems in the African-American community—the biggest one being that I'm not sure if they're going to elect me again. Maybe what I need to do is to deploy someone like you, someone who sits on the cusp of performativity, public good will, nuanced racial understandings, and political deference. Is it possible that we could leverage the Center to think about the future of transportation in black spaces?"

"Absolutely. Absolutely." I said, "Mayor, we are $10 million away from the resources that we need, and if the city of Chicago would commit $1 million toward the creation of art on 95th Street, then not only would I create the work of art on 95th but I would work with my colleagues to think about what are the best ways of imagining black space. Then that black space would become the kick-off for conversation within the Center, allowing us to connect the disparate departments of the Center for the Study of Race, Politics, and Culture with the Center for Latin American Studies, as well as unexpected centers like the Gary Becker Milton Friedman Institute for Research in Economics with the possibilities of cultural policy and the Harris School of Public Policy. When those centers get together, my hope is that there would not only be the emergence of a new knowledge, which is really important to this Center, but also the emergence of a new economic pathway within this Center. To this end, the first project that the Center will undertake is: how black space moves along the Red Line [a transportation line through Chicago]. The challenge my colleagues have is that they are not willing to go outside of their centers to imagine where the resources live. And the future of centers really depends upon our capacity to find and leverage these resources.

The mayor came back to me and said, "Theaster, the challenge that we're having is that we don't have solutions for the abandonments and blight that were created by the mayors before me. If there was a way to reestablish institutions in black neighborhoods, maybe you could help me gain the vote of poor people who could benefit from performative culture happening in their neighborhoods."

"Yes. Yes, yes, the Center understands black space. Yes, the Center is interested in experimentation. Yes, we want to experiment with black people in black space. Yes, this would become the core value of a new kind of intellectual inquiry at the Center." He asked me, "How will the Center do this?"

And that's the question. How will the Center do this? And one of the things I thought—I had to borrow this from Arnie Zane and Bill T. Jones—was if dancers have the capacity to allow non-dancers on stage and then create the kind of erratic composition of professional dancers and non-professional dancers, normal people working together on a stage for an audience, then these ideas of a deep melding and accepting of new possibilities within dance as a result of the lack of burden from a certain professionalized dance culture could tease out an emergent dance practice. New dance, we could dedicate homes to new dance. And I thought that if I applied these principles, these Jonesian principles, that they might also allow me to think about the possibility for our Center to take in professional black-space-thinkers with people who have a lived experience of black space. Then together they could create a new melded dance. This is exciting! And this is our Center!

I am asked, "Theaster, how might you do this? What is this issue of administration?" First, we have to recognize the most important cultural moments happening in the world and then imagine ourselves at the center of them. We must find a way to connect with curators, corporations, cities, chambers of commerce, people who really believe that culture is not only about the fifteen visitors that are willing to go to a museum but also about the tourists who come in every day to our cities, the hundreds of thousands of people who may become accidental professionals for one day if given the space.

Could the Center work to document the center of the center of the middle of the middle of the middle? Yes. Yes, through good administration and with hardy people who have never left the city—people who want to break free of the shackles of blight, the shackles of urbanism, the shackles of discontent that they have as a result of not having jobs. Is it possible for young little Nick—black,

despondent—to work with little John—white, Nordic—to create a kind of Bauhausian structure where the master, maker, and thinker would get together to create a kind of new offspring, an offspring of bi-racialism and bi-intellectualism. The Center should be in the center, as we get from Lawrence Weiner [conceptual artist]; the middle should be in the middle.

Maybe the Center also needs to consider other forms of non-artistic devices, partnering with our friends in the design and architectural communities. Maybe there's a way that we can learn something from Frances Stark [artist], David Adjaye [architect], Stephen Burks [designer]. Maybe there are things to learn from the Scandinavian movements and Italian movements. Not only do we have Arte Povera but we also have ovens and kitchens, doorways and hardwares. Surely these are things that the art historian and the artist might consider. We could talk about them not only from an economic viewpoint (which I'm very committed to), but also think about the deep and rich creativity that is embedded in these works. Could we create corporate manufacturers that have conceptual artistic values at their heart? And how do we produce this new artist? How do we celebrate and write about these new art forms? How do we expand notions of what art can do? I believe that under my tenure as director of the Center we will think about the *whole* artist. We will think about her production, her body. We'll ensure that she has an opportunity to both industrialize and renature—and that there will be processes of industrialization, renaturation, industrialization, renaturation.

Ultimately, it's important that we start to create physical positions within our cities, within our towns, on the hundreds of acres that we have in rural America, and that we should find centers next to centers. My hope is that over the next five years our Center will become an appendage to fifty other centers around the country. We would become an extension of the Clark so that if you have no interest in the possibility of converting this now largely white space into something more complicated, it's fine. Then what we should do, in fact, is create a center inside the center. And this is why Lawrence Weiner is so important—what Lawrence understands about the middle is that it has no edge.

Thank you.

Contributors

Caroline Arscott is professor of nineteenth-century British art and has been a member of the faculty at The Courtauld Institute of Art, London, since 1988, specializing in British art of the Victorian period. She is primary investigator on a United Kingdom Research Council–funded project *Scrambled Messages*, a four-year collaborative interdisciplinary project looking at the transatlantic telegraph as a source of metaphor in Victorian literature and art. She has published extensively on Victorian art and design. In 2008, she published *William Morris and Edward Burne-Jones: Interlacings*. From 2009 to 2014, as head of research at The Courtauld, she was responsible for its research strategy as well as Research Forum projects, events, and visiting scholar program. She has served as editor for ten years of the *Oxford Art Journal* and for five years of the *RIHA Journal*. In 2014–15, she was senior fellow at the Paul Mellon Centre for Studies in British Art, London, preparing a book on Victorian art, physics, and biology in the 1870s.

Manuel J. Borja-Villel is director of the Museo Nacional Centro de Arte Reina Sofía in Madrid. He received his undergraduate degree in art history from University of Valencia (1980) and his PhD from the Graduate School of the City University of New York (1989). He has written on Abstract Expressionism, various subjects in contemporary Spanish art, and invidual modern artists. As director of the Fundació Antoni Tàpies in Barcelona from its opening in June 1990 until July 1998, he organized such exhibitions as *The Limits of the Museum* and *The City of the People*. From July 1998 until January 2008, he directed the Museo d'Art Contemporani de Barcelona, where he curated *Antagonisms: Art and Politics*; *Force Fields: Phases of the Kinetic*; *Art and Utopia: Limited Action*; *Theatre without Theatre*; and *Be-Bomb: The Transatlantic War of Images and All that Jazz, 1946–1956*. In his current position since 2008, he has programmed such exhibitions as *Mixed Use, Manhattan*; *ATLAS: How to Carry the World on One's Back?*; *The Potosí Principle: How Shall We Sing the Lord's Song in A Strange Land?*; *Playgrounds. Reinventing the Square*; and *Biographical Forms: Construction and Individual Mythology*.

David Breslin is John R. Eckel, Jr. Foundation Chief Curator, Menil Drawing Institute, The Menil Collection.

Thomas Crow, the Rosalie Solow Professor of Modern Art, Institute of Fine Arts, New York University, is widely known for influential writings on the role of art in modern society and culture. His area of specialty ranges from eighteenth-century French art to modern and contemporary American art. He received his PhD in art history from the University of California–Los Angeles in 1978. He previously served as director of the Getty Research Institute and held professorships at University of Sussex and Yale University, among other institutions. His books include *Painters and Public Life in Eighteenth-Century Paris* (1985); *Emulation: Making Artists for Revolutionary France* (1995); *Modern Art in the Common Culture* (1996); *The Rise of the Sixties: American and European Art in the Era of Dissent* (1996); and *The Long March of Pop: Art, Music, and Design, 1930 to 1995* (2014). Crow is a contributing editor of *Artforum* and a member of the American Academy of Arts and Sciences. In 2015, he delivered the Andrew W. Mellon Lectures at the National Gallery of Art in Washington, DC.

Darby English is Carl Darling Buck Professor in the Department of Art History, the University of Chicago, and consulting curator in the Department of Painting and Sculpture, the Museum of Modern Art.

Patrick D. Flores, professor of art studies at the University of the Philippines and curator of the Vargas Museum, was one of the curators of *Under Construction: New Dimensions in Asian Art* in 2000 and the Gwangju Biennale (Position Papers) in 2008. He was a visiting fellow at the National Gallery of Art in Washington DC, in 1999. His publications include *Painting History: Revisions in Philippine Colonial Art* (1999); *Remarkable Collection: Art, History, and the National Museum* (2006); and *Past Peripheral: Curation in Southeast Asia* (2008). He co-edited an issue of *Third Text* (2011), focusing on Southeast Asia. In 2013, on behalf of the Clark Art Institute, he convened the conference *Histories of Art History in Southeast Asia* in Manila. He was a guest scholar at the Getty Research Institute in Los Angeles in 2014 and curator of the Philippine Pavilion at the Venice Biennale in 2015.

Theaster Gates is a Chicago-based artist who has developed an expanded practice that includes space development, object making, performance, and critical engagement with many publics. Founder of the non-profit Rebuild Foundation, Gates is currently director of Arts + Public Life, Office of the Provost, and professor in the Department of Visual Arts at the University of Chicago. Gates has exhibited and performed at the Studio Museum in Harlem, New York; Whitechapel Gallery, London; Punta della Dogana, Venice; Museum of Contemporary Art, Chicago; Santa Barbara Museum of Art; and dOCUMENTA(13), Kassel, Germany; among others. Gates has received awards and grants from Creative Time, the Vera List Center for Art and Politics, United States Artists, Creative Capital, the Joyce Foundation, Graham Foundation, Bemis Center for Contemporary Arts, and Artadia.

Kajri Jain is associate professor of Indian visual culture and contemporary art in the Department of Visual Studies and the Graduate Departments of Art History and Cinema Studies at the University of Toronto. Her research focuses on images at the interface between religion and vernacular business cultures in India; she also writes on contemporary art. She is the author of *Gods in the Bazaar: The Economies of Indian Calendar Art* (2007). Jain is currently working on a book on the emergence of monumental iconic sculptures in postliberalization India. Her recent publications include essays in the *Cambridge Companion to Modern Indian Culture* and *New Cultural Histories of India.* Jain has held positions in departments of art history, cultural studies, film studies, and anthropology in Australia, the United States, and Canada.

Anatoli Mikhailov is rector and founder of the European Humanities University, a university that he established in Minsk, Belarus, in 1992 in order to provide an alternative to the official Soviet educational process. In 2004, the Lukashenko regime closed the university, which relocated to Vilnius, the capital city of neighboring Lithuania, with the support of the Lithuanian government and the international community. A member of the Belarusian National Academy of Science, Mikhailov has lectured widely in Germany and the United States on German philosophy, phenomenology, Heidegger's fundamental ontology, and humanities methodology.

He has worked for the United Nations in New York and is a current member of the International Council at the International Centre for Democratic Transition in Hungary. Mikhailov has received many awards, including the French Academic Palm (2003), the Goethe Medal (2004), the Ion Ratiu Democracy Lecture Award (2007), and the Commander's Cross for Special Merit from the Republic of Lithuania (2008).

Mary Miller is Sterling Professor of the History of Art at Yale University, where she served as dean of Yale College (2008–14) and, before that, master of Saybrook College (1999–2008). A member of the American Academy of Arts and Sciences, she curated the highly acclaimed 2004 exhibition *The Courtly Art of the Ancient Maya*. Her major work on Bonampak, *The Spectacle of the Late Maya Court*, co-authored with Claudia Brittenham, was published in 2013. Miller is the author of *The Gods and Symbols of Ancient Mexico and the Maya* (with Karl Taube; 1993); *The Art of Mesoamerica* (now in its fifth edition); *Maya Art and Architecture* (with Megan O'Neil; 2014); and, with Linda Schele, *The Blood of Kings* (1986); as well as articles in many scholarly journals. Miller earned her AB degree from Princeton and her PhD from Yale. She gave the fifty-ninth Andrew W. Mellon Lectures at the National Gallery of Art in 2010 and the Slade Lectures at Cambridge University in 2015.

Molly Nesbit is professor of art at Vassar College and a contributing editor to *Artforum*. Her books include *Atget's Seven Albums* (1992) and *Their Common Sense* (2000). *The Pragmatism in the History of Art* (2013) is the first volume of *Pre-Occupations*, a series that will collect Nesbit's essays. Since 2002, together with Hans Ulrich Obrist and Rirkrit Tiravanija, she has curated *Utopia Station*, a collective and ongoing book, exhibition, seminar, website, and street project.

Howard Singerman is author of *Art Subjects: Making Artists in the American University* (1999) and *Art History, after Sherrie Levine* (2012). He has contributed essays to numerous exhibition catalogues, among them *A Forest of Signs* and *Public Offerings*, both at the Museum of Contemporary Art, Los Angeles, where he was museum editor from 1985 to 1988. His essays have appeared in a number of journals, including *Artforum*, *October*, *Oxford Art Journal*, and *La Part de l'Oeil*. Before his appointment as the Phyllis and Joseph Caroff Chair of Art and Art History at Hunter College, he was chair and professor of art history in the McIntire Department of Art at the University of Virginia. Singerman has also taught at Barnard College, the Art Center College of Design, the California Institute of the Arts, the University of California–Los Angeles, and the University of California–Irvine.

Photography Credits

Clark Studies in the Visual Arts

The Two Art Histories: The Museum and the University (2002)

Edited by Charles W. Haxthausen

With essays by Dawn Ades, Andreas Beyer, Richard R. Brettell, Stephen Deuchar, Sybille Ebert-Schifferer, Ivan Gaskell, Eckhard Gillen, Richard Kendall, John House, Patricia Mainardi, Griselda Pollock, Mark Rosenthal, Barbara Maria Stafford, Gary Tinterow, William H. Truettner, and Michael F. Zimmermann, and an afterword by Richard Brilliant

Art History, Aesthetics, Visual Studies (2002)

Edited by Michael Ann Holly and Keith Moxey

With essays by David Carrier, Philip Fisher, Hal Foster, Ivan Gaskell, Jonathan Gilmore, Thomas DaCosta Kaufmann, Michael Kelly, Karen Lang, Stephen Melville, Kobena Mercer, Nicholas Mirzoeff, W. J. T. Mitchell, Griselda Pollock, Irene J. Winter, and Janet Wolff

The Art Historian: National Traditions and Institutional Practices (2003)

Edited by Michael F. Zimmermann

With essays by Mieke Bal, Stephen Bann, Horst Bredekamp, H. Perry Chapman, Georges Didi-Huberman, Eric Fernie, Françoise Forster-Hahn, Carlo Ginzburg, Charles W. Haxthausen, Karen Michels, Willibald Sauerländer, Alain Schnapp, and Michael F. Zimmermann

Anthropologies of Art (2005)

Edited by Mariët Westermann

With essays by Hans Belting, Janet Catherine Berlo, Suzanne Preston Blier, Steve Bourget, Sarah Brett-Smith, Shelly Errington, David Freedberg, Anna Grimshaw, Jonathan Hay, Howard Morphy, Ikem Stanley Okoye, Francesco Pellizzi, and Ruth B. Phillips

The Lure of the Object (2006)

Edited by Stephen Melville

With essays by Emily Apter, George Baker, Malcolm Baker, John Brewer, Martha Buskirk, Margaret Iversen, Ewa Lajer-Burcharth, Karen Lang, Mark A. Meadow, Helen Molesworth, Marcia Pointon, Christian Scheidemann, Edward J. Sullivan, and Martha Ward

Compression vs. Expression: Containing and Explaining the World's Art (2006)

Edited by John Onians

With essays by Cao Yiqiang, Wilfried van Damme, Rita Eder, James Elkins, Arlene K. Fleming, Derek Gillman, Jyotindra Jain, Cecilia F. Klein, Yves Le Fur, Dominic Marner, Anitra Nettleton, John Onians, Edmund P. Pillsbury, Michael Rinehart, David Summers, and Georges S. Zouain

Asian Art History in the Twenty-First Century (2007)

Edited by Vishakha N. Desai

With essays by Frederick M. Asher, Melissa Chiu, John Clark, Gao Shiming, Yukio Lippit, Saloni Mathur and Kavita Singh, Kaja M. McGowan, Rana Mitter, Alexandra Munroe, Jerome Silbergeld, Nancy S. Steinhardt, Akira Takagishi, and Gennifer Weisenfeld

Architecture between Spectacle and Use (2008)

Edited by Anthony Vidler

With essays by Mario Carpo, Beatriz Colomina, Mark Dorrian, Kurt W. Forster, Hal Foster, Sarah Williams Goldhagen, Michael Hays, Mark Jarzombek, Felicity D. Scott, Terry Smith, Anthony Vidler, and Mark Wigley

The Meaning of Photography (2008)

Edited by Robin Kelsey and Black Stimson

With essays by Geoffrey Batchen, François Brunet, Mary Ann Doane, José Luis Falconi, Robin Kelsey, Douglas R. Nickel, Blake Stimson, John Tagg, and additional contributions by Lars Kiel Bertelsen, Anne McCauley, Jorge Ribalta, John Roberts, Eric Rosenberg, Eric C. Shiner, and Bernd Stiegler

Photo essays by Sharon Harper, Lilla LoCurto and Bill Outcault, Fiona Tan, and Akram Zaatari

The Migrant's Time: Rethinking Art History and Diaspora (2011)

Edited by Saloni Mathur

With essays by Stanley Abe, Esra Akcan, Iftikhar Dadi, Jennifer González, Ranajit Guha, May Joseph, Miwon Kwon, Kobena Mercer, W. J. T. Mitchell, Aamir R. Mufti, Nikos Papastergiadis, Richard J. Powell, Edward W. Said, and Nora A. Taylor

Fictions of Art History (2013)

Edited by Mark Ledbury

With essays by Paul Barolsky, Thomas Crow, Gloria Kury, Mark Ledbury, Ralph Lieberman, Maria H. Loh, Alexander Nemerov, Joanna Scott, Cole Swensen, Marianna Torgovnick, Caroline Vout, and Marina Warner

Art History in the Wake of the Global Turn (2014)

Edited by Jill H. Casid and Aruna D'Souza

With essays by Esra Akcan, Jill H. Casid, Parul Dave-Mukherji, Aruna D'Souza, Talinn Grigor, Ranjana Khanna, Kobena Mercer, Nocholas Mirzoeff, Steven Nelson, Todd Porterfield, Raqs Media Collective, Kishwar Rizvi, David J. Roxburgh, and Alessandra Russo